What Are You Doing Wrong* With Your Automatic Camera

*and how to do it right

DENNIS P. CURTIN / BARBARA LONDON

Curtin & London, Inc.
Somerville, Massachusetts

Van Nostrand Reinhold Company
New York Cincinnati Toronto Melbourne

Printed in the United States of America

Published in 1980 by Curtin & London, Inc.
and Van Nostrand Reinhold Company
A division of Litton Educational Publishing, Inc.
135 West 50th Street, New York, NY 10020, U.S.A.

Van Nostrand Reinhold Limited
1410 Birchmount Road
Scarborough, Ontario M1P 2E7, Canada

Van Nostrand Reinhold Pty. Ltd.
17 Queen Street
Mitcham, Victoria 3132, Australia

Interior and cover design: David Ford
Cover photograph: Henry A. Shull
Art and production manager: Nancy Benjamin
Illustrations: Omnigraphics
Photo research: Lista Duren
Composition: P & M Typesetting, Inc.
Printing and binding: Kingsport Press
Paper: 70# Patina, supplied by Lindenmeyr Paper Co.
Covers: Phoenix Color Corp.

Photo credits: see page 138

10 9 8 7 6 5 4 3 2 1

Library of Congress Cataloging in Publication Data

Curtin, Dennis, 1941–
 What are you doing wrong with your automatic
camera.

 Includes index.
 1. Electric eye cameras. 2. Single-lens
reflex cameras. 2. Photography—Handbooks,
manuals, etc. I. London, Barbara, 1936– joint
author. II. Curtin & London, Inc. III. Title.
TR260.5.C85 1980 770′.28′22 80-16721
ISBN 0-930764-20-X

Contents

1 Evaluating Your Choices 2

The Viewing Environment 4
Camera Handling Choices 6
Exposure Choices 8
Sharpness Choices 10
Color Choices 12

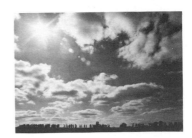

2 Color 14

Colors Not Rich and Bright 16
Colors Very Blue 18
Colors Very Orange-Red 20
Colors Very Yellow-Green 22
Colors Have Unexpected
Casts 24

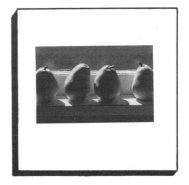

3 Camera Handling 26

Your Shadow in Picture 28
Vertical Lines Converge 30
Tilted Horizon Line 32
Entire Scene Not in Picture 34
Main Subject Very Small 36
Subjects Distorted 38
Picture Lacks Center of
Interest 40
Reflections Show 42
Distracting Background 44

4 Exposure 46

No Picture at All 48
Many Pictures Too Dark 50
Many Pictures Too Light 51
Subject Very Dark Against Light
Background 52
Subject Very Light Against Dark
Background 54
Problems at Night 56
Contrast Very Low 58
Snow Too Gray 60
Fog Too Gray 61
Lens Flare 62
Clouds Don't Stand Out 64

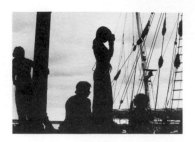

5 Sharpness 66

Image All Blurred 68
Moving Subjects Blurred 70
Foreground Sharp/Background
Not 72
Background Sharp/Foreground
Not 74
Wrong Part (or None) Sharp 76
Image Fuzzy 78

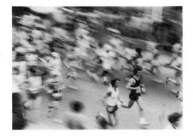

6 Flash 80

Only Part of Image Exposed 82
Flash Image "Ghosts" 83
Reflections of Flash Light 84
Eyeglass Reflections/Redeye 85
Prominent Shadows 86
Image Lacks Sense of Texture or
Volume 88
Subject Too Light 90
Subject Too Dark 91
Part Right/Part Too Light 92
Part Right/Part Too Dark 94
Center Right/Edges Dark 96
Too Dark/Too Light Outdoors or
in Large Room 97

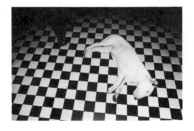

7 Miscellaneous Problems 98

Only Part Exposed 100
Uneven Exposure Across Frame 101
Corners Dark 102
Spots on Picture 104
Hair (or Other Marks) on Picture 105
Lines (Scratches) on Film 106
Torn Sprocket Holes 107
Overlapping Images 108
Static Marks 110
Light Streaked or Fogged 111

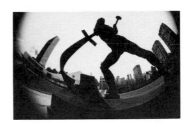

8 Preventing Problems 112

Care of Camera and Lens 114
Photographing in Bad Weather 116
Testing Your Film Speed 118
Exposure Compensation Controls 120
Quick Guide to Exposure Compensation 122

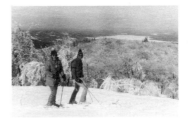

9 Improving Good Pictures 124

Introduction/Color Correction 126
Removing Spots from Prints 127
Cropping for Better Composition 128
Burning-in and Dodging 130

Useful Terms 132

Index 136

Photo Credits 138

Preface

If you are like other photographers, both amateurs and professionals, you take photographs with a certain expectation of how they will look in the final form. Have you ever been surprised after the film was processed? Have some of the pictures turned out just as you expected but others are either ruined by mistakes or improved by some happy accident? If so, then these pictures are the best learning experience you can have because, unlike photographs you see in books and magazines, you know how they appeared in the original scene. The mistakes you make can be eliminated in future photographs, and the happy accidents used as stepping stones to even better and more exciting photography . . . but only if you know what made the pictures appear as they do.

This book has been written and organized to guide you in learning photography as you photograph. It's an invitation to experiment and learn from the mistakes you make as you go along. It suggests that mistakes are often creative techniques used at the wrong time, or on the wrong subject, and suggests how these mistakes can be used creatively in other situations.

Unlike other books on photography that assume you have the time to read extensively before trying something new, this book encourages you to experiment and learn from your own results as you grow. Among other things it tells you:

> How to tell from your own pictures what caused a particular effect, such as lack of sharp focus, blurred motion, soft colors, light and dark exposures.

> How to eliminate your mistakes if they are the kind that detract from your photographs.

> How to use mistakes in other situations as creative techniques for better and stronger images.

> How to prevent problems and how to improve photographs you have already taken by using the services of a custom lab (or your own darkroom).

Special symbols, located at the bottom of some pages, are designed to refer you to other sections of the book where related material is discussed.

℞ This symbol, followed by a word, guides you to the section of Chapter 9 that demonstrates how pictures can be improved after they have been taken.

▶ This symbol refers you to other pages of the book where related problems are discussed.

1 Evaluating Your Choices

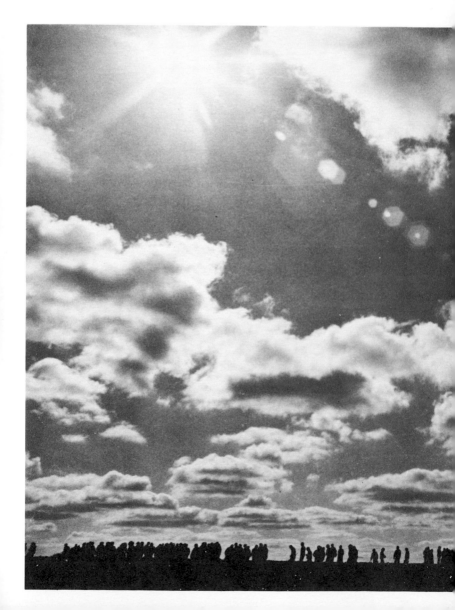

The Viewing Environment Sharpness Choices
Camera Handling Choices Color Choices
Exposure Choices

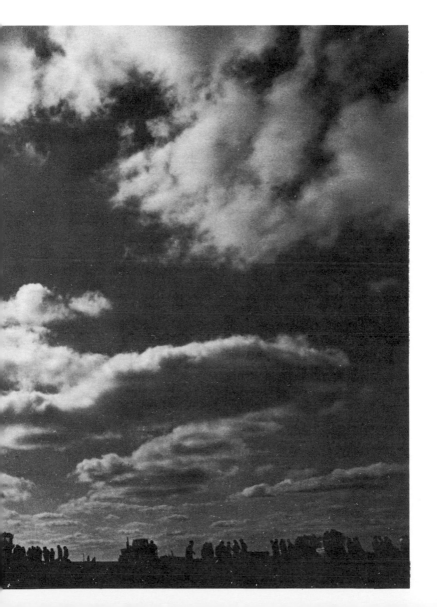

The Viewing Environment

The first step in evaluating a print or slide is to examine it carefully. Ideally, the brightness and color of the light should be the same as that under which the picture finally will be viewed. This is seldom completely practical, but you should at least be aware that viewing conditions affect the way a picture looks. Although none of the equipment shown in this section is absolutely necessary, you will find that some of it can be very helpful.

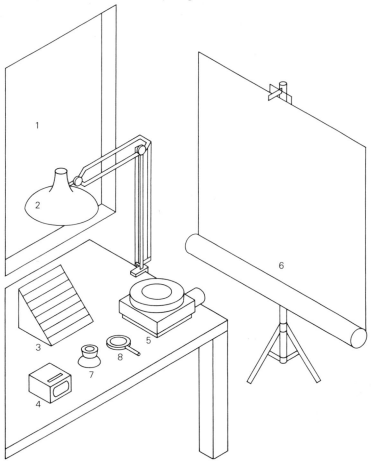

VIEWING YOUR PRINTS

Brightness of light. Either window light (1) or electric light (2) can be used for viewing, as long as it is bright enough to see details clearly. Avoid very dim light—not only will the print be hard to examine but it will appear darker than when you show it under average illumination. Very bright light is good for examining fine details, but don't use it to evaluate overall lightness or darkness because the print will appear lighter than it will under average conditions.

Color of light. A color print viewed in daylight will appear slightly bluer than the same print viewed in tungsten light, such as from a household bulb. For viewing color prints Kodak recommends fluorescent tubes such as Westinghouse Living White or the Deluxe Cool White tubes made by various manufacturers. For a mixture of tungsten and fluorescent light, Kodak recommends a 75-watt frosted tungsten bulb for each pair of 40-watt Deluxe Cool White fluorescent tubes.

VIEWING YOUR SLIDES

A slide sorter (3), a translucent surface with a light behind it, is useful for organizing slides. Ridges keep the slides from falling off the inclined surface. Horizontal models are also available. A table-top slide viewer (4) provides a somewhat enlarged projection, convenient for viewing a few slides at a time. A slide projector (5) provides more enlargement and makes it easier to view a large quantity of slides. A screen (6) is useful but a white wall or other surface can be used.

MAGNIFIERS

Sharpness in a print or in a nonprojected slide is easier to evaluate with some kind of magnification. A photographic loupe (7), somewhat like the magnifier used by jewelers, provides about 8X magnification. A magnifying glass (8) provides a view of a larger area than a loupe does, but generally not at as great a magnification.

Camera Handling Choices

Every time you make a photograph, you make choices—whether
you think very much about them or not. Did you position the
camera up close to the subject or far away? Did you accept the
automatic exposure provided by the camera or override it? Did you
select camera settings for maximum sharpness or not? Since all
of these choices affect how the photograph looks, the more you
become aware of your options, the more control you will have over
your picture making—and the more pleasure you are likely to
have when you look at the results. This page and the one opposite
illustrate some basic camera handling choices. More about these
choices—and related problems—appears on pages 26–45.

*How much of the subject to show is
one of the first choices you have
to make. Often the impulse is
to step back to get the entire sub-
ject, or as much of it as possible,
visible in the viewfinder. Overall
shots (like the one below) are
fine, but sometimes a detail (at
right) tells it all.*

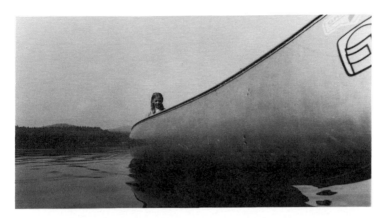

Objects, or parts of them, that are close to the camera appear larger in a photograph than objects that are very far away. You can, if you choose to do so, distort a subject if one part of it is much closer than the rest. Above: a girl appears very small and far away at one end of a giant canoe because the photographer was very close to the bow while the girl was relatively far away in the stern. Below: a similar scene appears in more realistic proportions because the photographer was far enough away from all important parts of the scene so that no part appears exaggerated.

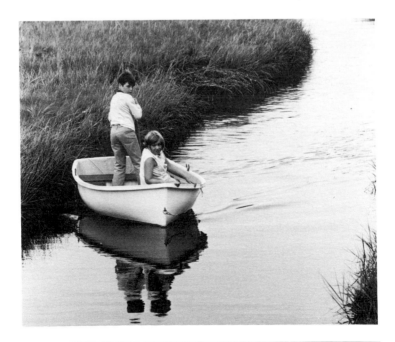

Exposure Choices

Automatic exposure cameras produce excellent exposures for scenes with a more or less even mixture of light and dark tones— for example, the Roman scene below. But you can, if you wish, choose to override the automatic exposure for a particular result. More about exposure choices on pages 46–65.

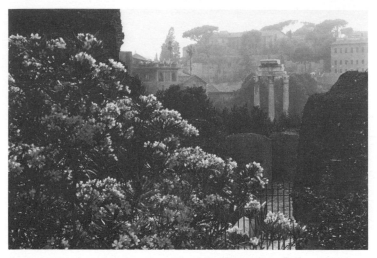

Above: automatic exposure worked well in this daylight scene. Below: the photographer chose to override the automatic exposure in a night scene of dark buildings and bright lights.

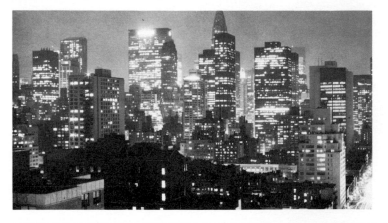

Above: backlit or other scenes where the background is much brighter than the main subject can underexpose the subject so that it is very dark, even a silhouette. You can exploit this, as here, or increase the exposure for a more realistic effect. Below: dark shadows enhance a close-up portrait of a boxer—and his knuckles.

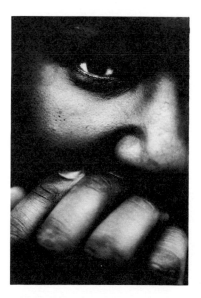

Sharpness Choices

Sharpness or the lack of it is easy to see in the final photograph, but when you are taking the picture you may not be able to tell exactly how sharp the results will be. More about sharpness and how to control it on pages 66–79.

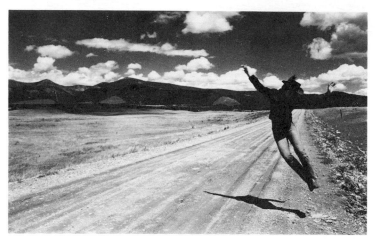

Moving subjects can be sharp or blurred, depending in part on the shutter speed. Above: an exuberant jump was frozen sharply by a fast shutter speed. Below: a slow shutter speed blurred the dancers' arms and torsos. Their feet are relatively sharp because they were not moving as much.

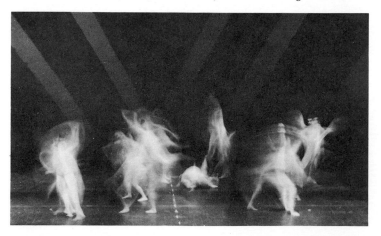

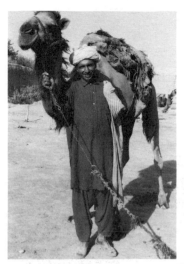
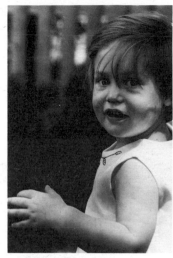

How sharp a stationary subject is from foreground to background depends on the size of the lens aperture, among other factors. Above left: you can choose to have the entire scene sharp from foreground to background; a small aperture helps. Above right: you can make an unimportant part of a scene (here, the background) less prominent by photographing it out of focus; a large lens aperture was used. Below: you can also choose to have an important part of a scene out of focus. The sharp camel contrasts with the out-of-focus nomad woman in the background.

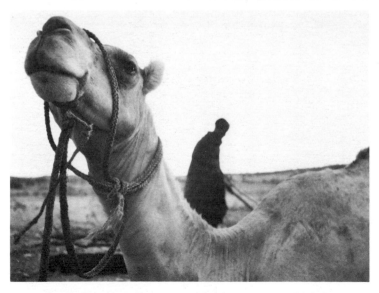

Color Choices

Color in a photograph can enhance the subject matter, be neutral and unobtrusive, or be a distracting element. More about color choices on pages 14–25.

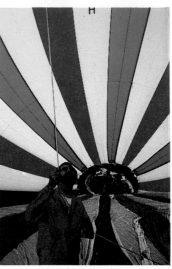

Right: bright, contrasting colors are vibrant in this picture taken inside a hot air balloon on a sunny day. Below: early morning fog and an overcast sky made colors muted and bluish in this farm scene. Objects farther away were more muted by the fog than those closer to the camera.

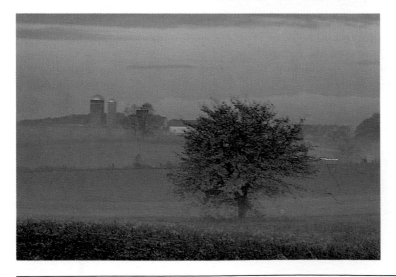

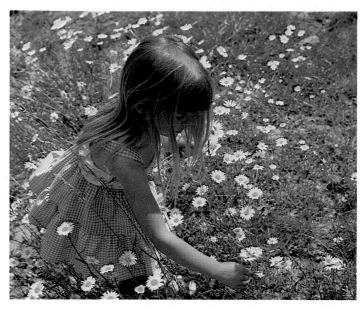

Above: the colors of certain objects like human skin and green grass are familiar and the eye expects them to stay within a certain normal range, as here. Too much shift away from normal will be readily noticeable. Below: considerable variation is tolerated in sunsets or scenes where colors are not known. You can control colors in a photograph to a certain extent with filters over the lens.

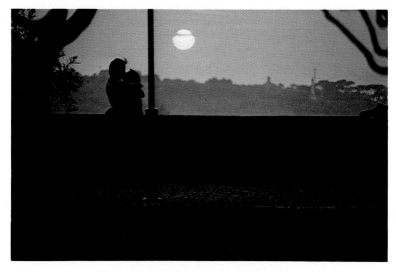

2 Color

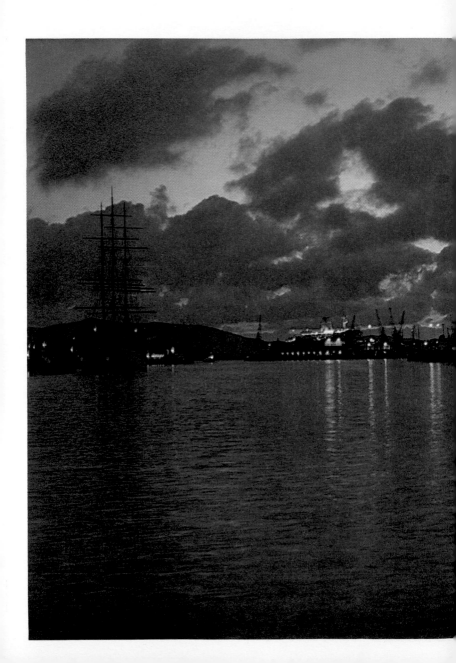

Colors Not Rich and Bright
Colors Very Blue
Colors Very Orange-Red

Colors Very Yellow-Green
Colors Have Unexpected Casts

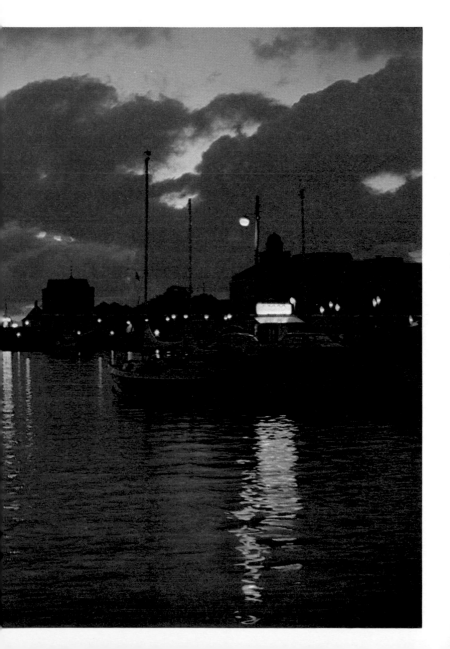

Colors Not Rich and Bright

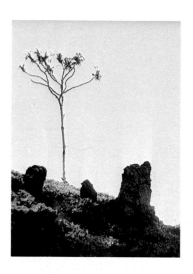

You can control the intensity of colors by varying the exposure you use. The colors will appear bright and intense only when exposed properly. Too much exposure (overexposure) will cause colors to look weak and washed out; too little (underexposure) will make colors dark and without detail. Color reversal (slide) film is more sensitive to exposure variations because the final slide is the actual film used in the camera. With print film (either color or black-and-white) the film is developed to make a negative, and slight variations can be corrected when enlarged prints are made.

> *Film speed* (ASA, DIN, or ISO) was not set correctly on camera. If an occasional roll is under- or overexposed, you may not have entered the correct film speed into the film speed dial. If it happens continually, then the manufacturer's recommended film speed may not be ideal for your camera. (To determine your own personal film speed, see p. 119.)

> *Picture was taken on brightly lit sand or snow,* causing your auto-exposure system to underexpose the scene. Increase the exposure about 1 stop in these situations. (See exposure compensation, pp. 120–123.)

Because exposure is so critical, it is wise to bracket important shots by first shooting at the automatic setting (or at the setting you prefer) and then using exposure compensation to slightly overexpose and underexpose additional pictures of the same scene. The best exposure can then be selected after you process the film.

Ŗ Color correction, p. 126 ▶ p. 51

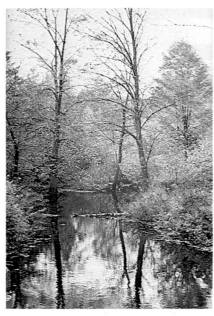

Colors that are not rich and bright can add interest and visual appeal to some scenes. Above: light fog and slight overexposure paled the golds and greens of this autumn scene into soft, shimmering tones. Below: a very bright background flared into the lens, causing colors and details to become foggy—and the subject to become an abstracted but still recognizable shape (more about flure on pp. 62–63).

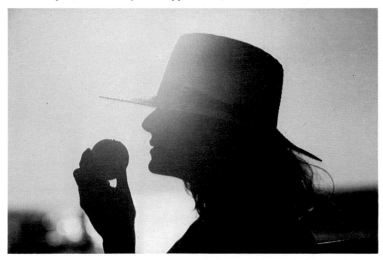

Colors Very Blue

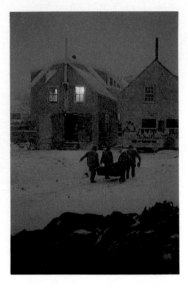

If you stand outside a house at dusk, it is easy to see how bluish the light outside looks compared to the golden glow from lamps inside the house. Ordinarily we don't notice a color cast in the light illuminating a scene unless we have light of another color to compare it with or unless the color cast is extreme.

In human vision, the brain makes adjustments so that colors seem to appear as we expect them to, but color film does not make these adjustments. If the light on a scene is bluer than the light that the film was designed to record accurately, then the picture will appear too blue.

Any situation where the light is excessively rich in bluish or ultra-violet rays will cause pictures to be too blue. For example:

> *Pictures taken in the open shade* (where the subject is illuminated by the blue of the sky but not by direct rays from the sun).

> *Pictures taken at high altitudes* in the mountains or from airplanes.

> *Pictures taken on overcast days.*

The correct filter over the lens will absorb some of this blue light and give pictures a more natural color balance. A UV ultraviolet filter or a 1A skylight filter reduces the blue cast; an 81A light yellow filter decreases bluishness even more and gives a slightly warm tone to the scene.

> *Tungsten-balanced (indoor) film used in daylight or with electronic flash* will also give a blue cast to pictures. Use an 85B amber filter or change to daylight film.

℞ Color correction, p. 126 ▶ pp. 24–25

Here a blue cast enhances the feeling of the pictures. Above: bluish tones are often associated psychologically with cold subjects like snow and ice; shades of blue are even called ''cool'' colors. The pale blues and grays add to the wintry feeling of the scene. Below: you can deliberately increase the blue tones in a picture by placing a blue filter over the lens. Underexposing the film, as was done here, produces an effect that looks very much like a moonlit scene.

Colors Very Orange-Red

Although it is not often noticeable to the eye, there is a difference in the kinds of "white" light by which we take pictures. Light from a household tungsten bulb or from an early morning sun is warmer (more orange-red) than is the light from the midday sun.

Film is designed for a specific balance of colors. Daylight-balanced film, for example, produces natural-looking colors when used in the blue-white light of midday sunlight. The same film used in a light that has more reddish rays will cause pictures to have a warm orange or reddish tone (see picture at left).

> *Daylight film used in early morning or late afternoon* will generally have a warmer orange-red cast to it than the same film will have when used in midday. The sun's rays travel a longer distance through the earth's atmosphere at these times, which scatters the blue light leaving more red light to affect the film.

> *Daylight-balanced film used indoors under tungsten light* will record colors with the orange-red cast emitted by tungsten bulbs. Use an 80B filter or change to tungsten-balanced (indoor) film.

> *Candlelight or firelight illumination* will cause any color film to record a scene in warm orange-red tones. These tones often add to the feeling and mood of the picture.

℞ Color correction, p. 126 ▶ pp. 24–25

Right: sunset scenes are usually orange-red in tone—sometimes intensely so. Almost any tone of orange or red is believable in a sunset sky. Center: grasses lit by sunset light have picked up an orange tone that clearly says "sunset," even though the sky isn't visible. Bottom (and opposite): warm tones on skin generally look pleasing and natural; there is no need to filter the light to remove this warm cast.

Colors Very Yellow-Green

If you are shooting indoors under illumination from lamps or electric lights, it is natural to load your film with tungsten-balanced (indoor) film. Yet you may find that these pictures come back with an unattractive yellow-green cast to them. If they do, the chances are that some or all of the light came from fluorescent fixtures. Fluorescent light may be somewhat reddish or somewhat bluish but always contains a large amount of green light.

> *Fluorescent illumination* gives scenes a greenish cast. The color balance depends on the type of fluorescent tube and on its age, so color balance can't be predicted exactly in most cases. An FL fluorescent filter has a magenta color that helps remove most of the green. Use an FL-D filter with daylight-balanced film, an FL-B filter with tungsten-balanced film.

Your choice of film can also improve the color balance. High-speed negative films such as Kodacolor 400 produce pictures with an acceptable (if not perfect) color balance even when shot under fluorescent light without a filter. In general, daylight-balanced films give better colors than do tungsten-balanced films, if no filter is used.

R̲x̲ Color correction, p. 126 ▶ pp. 24–25

Right and center: although the greenish light from fluorescent illumination is seldom desirable, an overall greenish cast to a leafy scene outdoors can add to the feeling of green vegetation. Bottom: green pears, reflecting a greenish light onto the window frame and sill, bathe their surroundings with green tones.

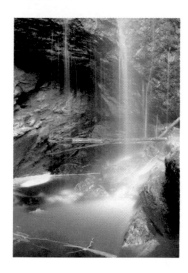

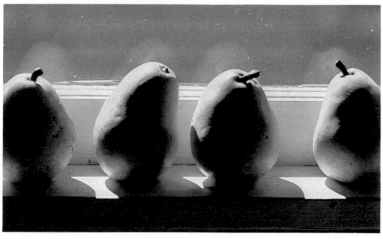

Colors Have Unexpected Casts

The colors of a subject as they are recorded on your film depend on several variables ranging from the color of the subject itself to the light used to illuminate it to the characteristics of the film.

> *Reflections from nearby colored surfaces* such as painted walls, green foliage, and so on, can all affect the color of the subject (see picture above). Move the subject away from brightly colored surfaces, especially those that are shiny or are brightly lit.

> *Mixed lighting* of daylight from windows combined with tungsten light from lamps will look partly reddish if you are using daylight film or partly bluish if you are using tungsten film. Use daylight film in these situations, especially with portraits; the lamps will shift the colors to warmer tones that are not unattractive on skin tones. Mixtures of other light sources such as tungsten plus fluorescent fixtures have results that are hard to predict.

> *Reciprocity effect* (changes in film response due to long exposures) will shift colors with many films when exposures over 1 second are used. Open your aperture to keep your shutter speed below 1 second or try a faster film.

> *Film that is outdated, stored incorrectly, or badly processed* may have a greenish or other unwanted cast. Use color film before or shortly after the expiration date printed on the film box. Avoid storing film where temperatures are high, such as in an automobile glove compartment in summer. Process film promptly after exposure, and find a lab that does consistent, high-quality work.

Ṛ Color correction, p. 126

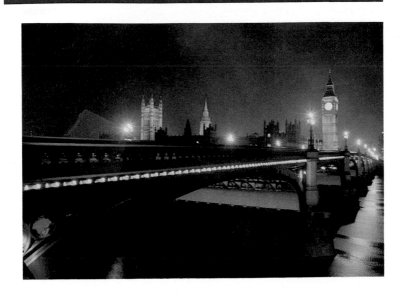

Above: a long exposure of a London bridge in the evening produced an unexpected and unusual yellow cast because of reciprocity effect (the color shift caused by a long exposure) and the type of light source illuminating the scene (often impossible to determine). Below: red lighting reflects off the artificial smoke on stage at a rock concert. A red filter over the lens would have increased the red tones even more.

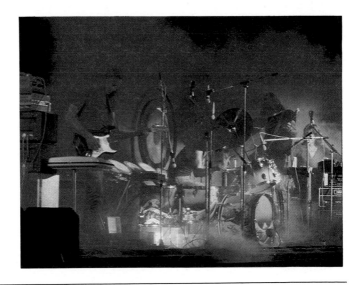

3 Camera Handling

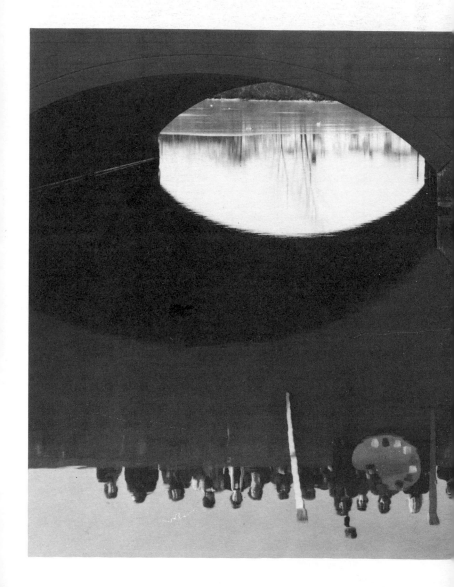

Your Shadow in Picture
Vertical Lines Converge
Tilted Horizon Line
Entire Scene Not in Picture
Main Subject Very Small

Subjects Distorted
Picture Lacks Center of Interest
Reflections Show
Distracting Background

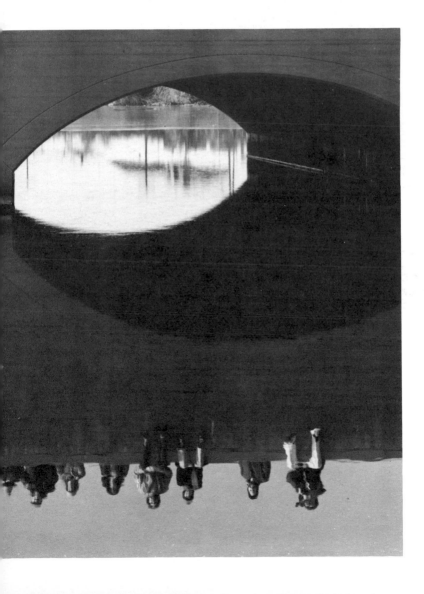

Your Shadow in Picture

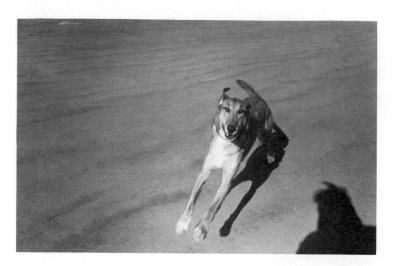

Anyone who has ever taken a lot of photographs has at least one with their shadow projecting out of the bottom of the picture into the image area. This is the result of shooting with the light (usually the sun) at your back.

Your shadow in the picture always means that the light source was behind you.

> *Move your camera or the subject* so that the shadow you cast falls outside of the image area. Tilting the camera up will include less of the shadow or eliminate it entirely, but may cut into the subject. Kneeling may make your shadow small enough so it doesn't intrude. Turning so the light is more to one side instead of directly behind you will cause your shadow to fall to one side and out of the frame.

> *Use a longer focal length lens from farther back.* This will eliminate the area in your immediate vicinity from the picture and so eliminate your shadow. However, it may be difficult to move far enough back without some other object getting in the way.

℞ Cropping, pp. 128–129

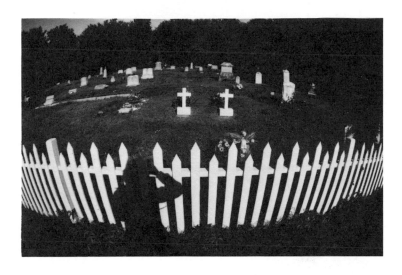

Shadows can be a distracting element, or—as here—add interest to a
picture. Above: a shadowy visitor to a graveyard makes this photograph
more engaging than it would be without the shadow. The apparently
curved line of the fence is caused by using a very wide angle lens very close
to the subject. Below: shadows of other objects can also add interest.
The shadow of a nearby structure overlays a solid, symmetrical form on
what would otherwise be a rather ordinary corner of a building.

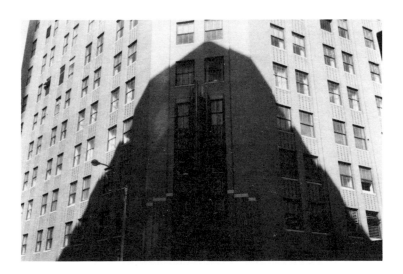

Vertical Lines Converge

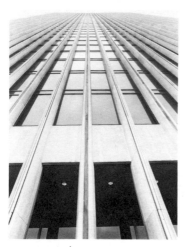

When photographing a building, you may be tempted to get every last inch of it into the picture (above left). It's only when you see the picture after processing that you notice that the sides of the building appear to lean together.

Although it is relatively easy to accept convergence in a picture of a tall building, the same phenomenon is often less acceptable in photographs taken indoors (above right).

Lines that are parallel in a scene will photograph that way only when kept parallel to the film plane in the camera. If the camera is tilted back—for example, to get the top of a building in a picture— the part that is closest to the film (the lower floors) will be bigger in the image than the part that is farther away (the upper floors), and the vertical lines of the building will appear to converge.

> *Keep the camera back and the lines of the subject parallel.* Lines will not converge, but you may lose part of the scene.

> *Move farther back.* Although the main subject will be smaller, it will also be more square because you won't have to tip the camera as much to get it all in.

> *Use a shorter focal length (wide-angle) lens,* which will have a wider angle of view. The increased coverage may allow you to get the entire scene in without tilting the camera.

▶ pp. 38–39

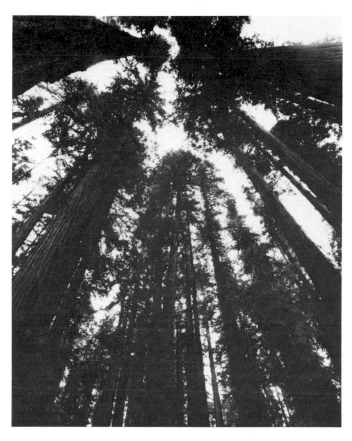

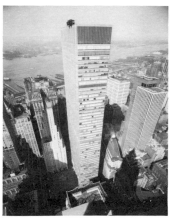

Above: trees converge and loom overhead when the camera is pointed upward. The trees are in fact tall, but appear even taller because of the convergence. Right: the same effect occurs in reverse when the camera is pointed downward. The part of the subject closest to the camera (here, the top floors of the buildings) appears larger in the picture than the part that is farther away (the bottom floors). The bottoms of the buildings converge and gives the impression of dizzying height.

Tilted Horizon Line

Seascapes and flat landscapes with large expanses of horizon can be diffi-cult to photograph so the horizon line appears absolutely parallel to the top and bottom of the picture frame. The horizon may appear perfectly aligned on the small viewfinder screen but a slide or enlarged print will magnify any tilt. Buildings or other objects with horizontal lines also look odd if they tilt too much. Even if no horizontal lines are visible, a picture that tilts too much to one side can feel unbalanced.

> *Check to make sure the horizon line is straight* before you shoot, even if the main subject of interest is elsewhere in the scene. Although the main subject appears most important at the time the picture is taken, the background will be quite noticeable in the final photograph.

> *When photographing from a boat,* where the rocking motion makes the horizon line continually shift in relation to the camera, try to coordinate your exposure with the boat's roll. If you compose your picture on one roll of the boat and then align the horizon and take the picture on the next roll, you will have more time to con-centrate on keeping it level.

> *Use a tripod* so you can first align your camera for a level horizon and then concentrate on the main subject.

℞ Cropping, pp. 128–129

Although a slightly tilted horizon line may look like a mistake, an obviously tilted picture, especially of an already tilting subject, can add to the giddy excitement of the scene.

Entire Scene Not in Picture

The key to successful photographs is to isolate and frame details out of all of the visual opportunities that present themselves. Not only is a view that shows everything you see often impossible, but more frequently it is undesirable. Often, however, the group, the landscape, or the city view you want to capture is too large to get into the picture area. When this is your goal you can increase your overall coverage in various ways.

> *Move farther back.* The farther the subject is from the camera, the more will be visible. Everything will be smaller but at least it will all be in the picture.

> *Use a shorter focal length (wider angle) lens.* The shorter the focal length, the wider the angle of view the lens will have.

> *Get a group (of people or objects) closer together.* If you photograph a group of people with some standing, some sitting on chairs, and some on the floor you will almost always have a more interesting picture than if they line up like soldiers on parade.

> *Isolate details.* Don't try to capture the entire scene; instead choose those details that are most interesting. Often a small detail expresses the idea better than an overall view.

> *Check the edges of your viewfinder* before you make an exposure to make sure you are not cropping into the subject.

℞ Cropping, pp. 128–129

Showing only part of the subject often can be better than showing the whole thing. Right: a flamingo, all neck and legs, burrows for food. Below: there is usually no way to show a complete view of the Great Buddha at Kamakura without also showing other tourists at this popular Japanese shrine. Here the photographer moved in to a powerful detail of just the hands in their position of meditation. Bottom: peanut and elephant meet. The photographer has captured the critical part of the transaction.

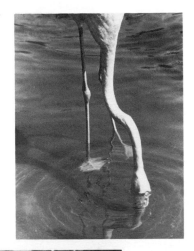

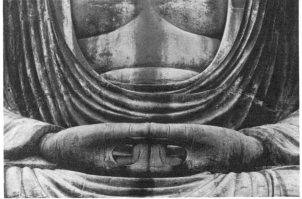

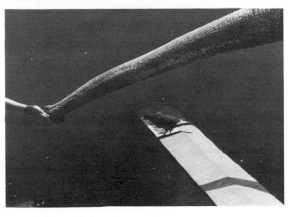

Main Subject Very Small

A famous photojournalist, Robert Capa, once said, "If your pictures aren't good enough, you aren't close enough." The character of people is usually best captured from a vantage point that is close enough to show their expressions; photographing relatively close can eliminate distracting objects from the edges of the image so that the eye concentrates on the main subject. If your main subject appears too small, it is usually because you aren't close enough.

> *Move closer to the subject* so that it appears larger in the view-finder. When photographing people this isn't always the best solution because very close distances increase their awareness of you and their self-consciousness. Distances closer than 3 or 4 feet also distort facial features such as nose or chin so that they appear out of proportion.

> *Use a longer (telephoto) lens,* which optically enlarges the subject without requiring you to move closer physically.

> *Use close-up equipment* for very small objects. A macro lens works just like a normal lens for general photography but also allows you to focus very close. You can also enlarge small objects in your pictures by using extension tubes, bellows, or screw-on close-up lenses.

Ŗ Cropping, pp. 128–129

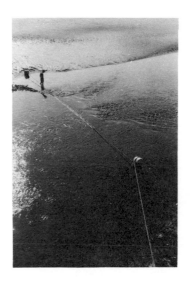 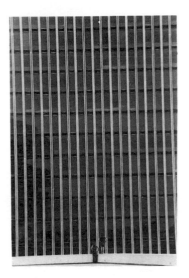

Keeping the subject small can emphasize the size of the surroundings so that the "subject" becomes the entire environment. Above left: the viewer's eye goes first to the child—a small, human part of a large expanse of water and sand. Then the eye travels along the rope and float, which are strong visual connections to the edges of the picture. Above right: people and modern architecture take each other's measure. Below: a very small boat ventures across a very large sea. A solo voyage across the Atlantic might have this feeling.

Subjects Distorted

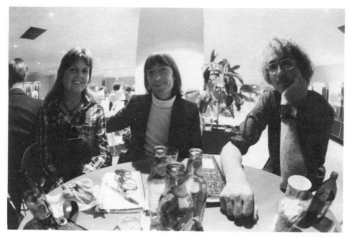

The closer objects are to your camera, the larger they will appear in the photograph. This effect normally gives scale and a feeling of distance between objects in a photograph, but in some cases the subject appears distorted. The most noticeable and commonly encountered example is when you photograph a person with one part of his or her body significantly closer to the camera—and therefore much larger—than other parts are. A portrait from up close can be particularly unflattering. The nose, being closest to the camera, is enlarged out of proportion to other parts of the face that are farther from the camera.

> *Move farther back.* Even though the subject will be smaller it won't be distorted.

> *Use a longer focal length lens* so you can stand farther from the subject while retaining its size in the photograph. For portraits, lenses between 85mm and 135mm in focal length are ideal because the portrait still fills the frame when the camera is far enough from the subject to eliminate any distortion.

> *Photograph the person in his or her environment.* This not only increases your distance from the subject (and thereby lessens distortion) but also tells something about how the person lives.

> *Equalize the distance from the camera* of various parts of the subject, if possible.

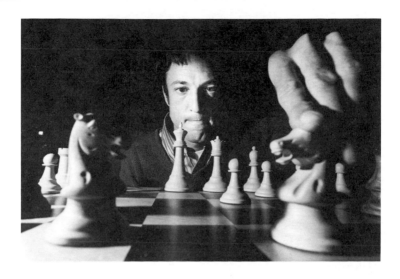

Distortion can add drama and meaning to a photograph. Above: a black pawn's view of a white knight in action. The hand and chess piece are very large because they are very close to the camera. Below: the photographer and camera look down on a small child and produce the same effect as in the city scene on page 31, a towering feeling of height. The child, with a somewhat doubtful expression, seems to be wondering what to expect from this looming adult.

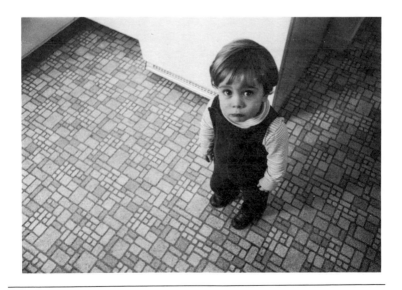

Picture Lacks Center of Interest

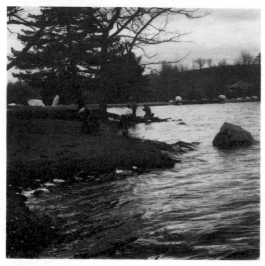

One of the exciting aspects of photography is that there are no rules that determine what makes an interesting picture. The variety of possibilities is almost endless. This doesn't mean, however, that every photograph is interesting. The majority of photographs, even those taken by profession- als, fail to arrest one's eye, often because they lack a center of interest that captures attention and draws the viewer into the picture. This lack of a compelling center causes one's eye to wander in search of meaning and interest.

> *Use selective focus* to throw the background out of focus and better isolate the central subject.

> *Move the camera or subject* to eliminate distracting elements.

> *Change the camera angle* and shoot up, down, or at an angle rather than always shooting straight ahead.

> *Watch the edges of the image frame* and remember that they will be as important in the final photograph as the center is. Think of the edges as an actual frame around the picture, one that can enhance the image by focusing your attention on the main subject.

℞ Cropping, pp. 128–129; Burning-in, p. 130

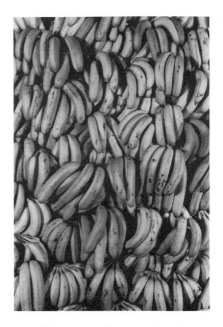

You don't have to have a single, compelling center of interest for a photograph to capture your attention. Above: a solid wall of bananas forms an overall pattern that invites the eye to wander among its curves. Below: no single alligator commands any particular notice, but all together they form an eyestopping heap.

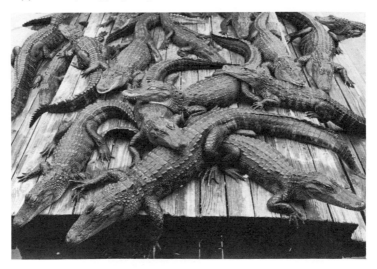

Reflections Show

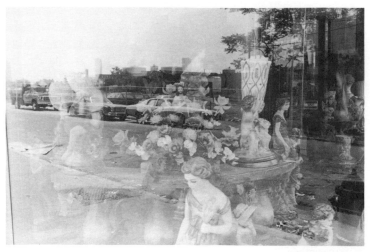

If reflections in a window or other shiny surface turn out to be more notice-able in a photograph than you thought they were when you took the picture, the chances are that you were concentrating so much on the things inside the window or on the general scene that you simply didn't notice how bright the reflections were. Reflections are particularly evident when the background or reflecting surface (here, the window display) is darker than the objects being reflected (the street and cars).

> *Move around the subject* and view it from different angles; the reflections will change as you change your point of view and may be more acceptable from another position.

> *A polarizing filter* helps decrease reflections from nonmetallic surfaces such as glass or water. Attach the filter to the front of the lens, look at the scene in the camera viewfinder as you rotate the filter until the best results are achieved, then leave the filter in that position while you take the picture.

You don't necessarily have to remove reflections. Try making them a part of the picture. Top: twin reflections of the photographer silhouetted against brightly lit windows merge a portrait with a self portrait and mix the subject's view with the photographer's view. Bottom: the reflection of mountain, trees, and cliffside in a lake is almost a mirror image of the original scene.

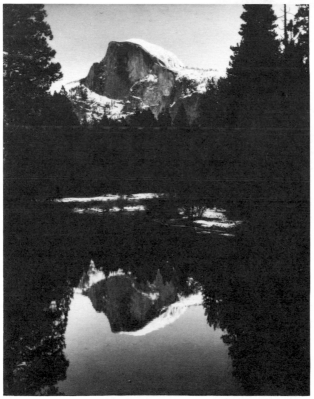

Distracting Background

It is easy to concentrate so much on the main subject in the scene that you forget to look at the background and think about how it will appear in the final image. Likely results include trees appearing to sprout out of your subject's head, busy and confusing details in the background that draw the eye away from the subject, and a whole collection of other possible distractions from the main image.

> *Failure to see the entire picture area when taking a photograph.* There is a tendency to look at only the central part of the viewfinder since that is where you concentrate when focusing. Make it a habit to examine the entire picture area. After focusing, look at the environment in which the subject is placed and at the edges of the image frame.

> *Move the subject or the camera.* This will allow you to place the main subject against a less distracting background, perhaps against a clear sky or a dark shadow area.

> *Use selective focus.* A large aperture reduces the depth of field and this may enable you to have the background appear soft and out of focus so it doesn't visually detract from the main subject.

> *Move closer to the subject,* reducing the area around it to cut out some of the distracting elements. Moving closer also reduces the camera's depth of field and makes more of the background likely to be out of focus.

> *Use a longer focal length lens.* Like moving closer, this reduces the total area in your picture so that your subject fills more of the frame. Longer lenses also have less depth of field for better out-of-focus effects on the background.

℞ Cropping, pp. 128–129; Burning-in, p. 130

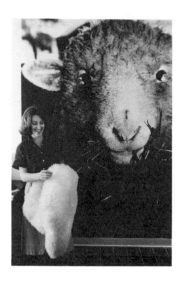

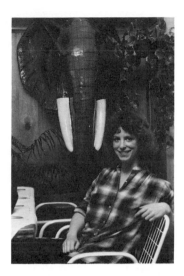

A prominent background doesn't have to be distracting; it can tell something about the main subject or just add visual interest. Above left: a woman selling sheepskin products is supervised by an oversized sheep on a wall mural. Above right: an elephant joins a woman for lunch. Below: people on a wall mural line up behind a group of boys. The photographer arranged the boys by height and then positioned the camera so the boys' heads blend into the mural.

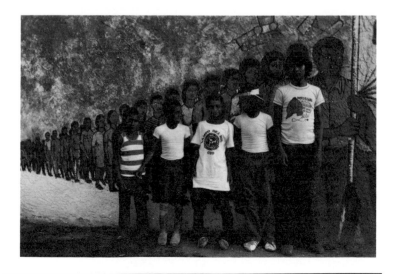

4 Exposure

No Picture at All
Many Pictures Too Dark
Many Pictures Too Light
Subject Very Dark Against Light
Background
Subject Very Light Against Dark
Background

Problems at Night
Snow Too Gray
Fog Too Gray
Contrast Very Low
Lens Flare
Clouds Don't Stand Out

No Picture at All

	How It Looks	Description
SLIDES		Both image area and edges are clear.
		Image area is clear but edges are black (except for film frame numbers).
		Both image area and edges (except for film frame numbers) are black.
NEGATIVES		Both image area and edges are black.
		Image area is black but edges are clear (except for film frame numbers).
		Both image area and edges (except for film frame numbers) are clear.

Causes

Overexposed to light but not through the lens/shutter.

> Camera back inadvertently opened (usually affects only part of the roll). If this happens, close the camera back quickly and advance the film 3 or 4 frames and resume shooting.

Overexposed to light through the lens/shutter.

> Massive overexposure because of wrong (much too low) film speed entered on camera's film speed dial.
> Aperture failed to stop down.
> Shutter sluggish or failed to close (especially in cold weather).
> Shutter was set at "B," causing massive overexposure.

Film not exposed to light.

> Film not put in (or not run through) the camera.
> Flash failed to fire.
> Shutter accidentally released with lens cap left on.
> Shutter failed to open or mirror failed to move up.

Overexposed to light but not through the lens/shutter.

> Camera back inadvertently opened (usually affects only part of the roll). If this happens, close the camera back quickly and advance the film 3 or 4 frames and resume shooting.

Overexposed to light through the lens/shutter.

> Massive overexposure because of wrong (much too low) film speed entered on camera's film speed dial.
> Aperture failed to stop down.
> Shutter sluggish or failed to close (especially in cold weather).
> Shutter was set at "B," causing massive overexposure.

Film not exposed to light.

> Film not put in (or not run through) the camera.
> Flash failed to fire.
> Shutter accidentally released with lens cap left on.
> Shutter failed to open or mirror failed to move up.

Many Pictures Too Dark

Dark photographs occur when film is underexposed (not exposed to enough light). If this occurs on only some pictures on a roll, the cause was most likely a metering problem. If an entire roll (or rolls) has this problem you may have set the controls (film speed, exposure compensation) incorrectly or you may have a camera malfunction.

> *Light too dim for the aperture or shutter speed selected.* In automatic operation, your selected aperture required a slower shutter speed (or your selected shutter speed required a wider aperture) than your camera could provide. In manual operation, you set in too fast a shutter speed, too small an aperture, or both.

> *Wrong film speed entered into film speed dial.* If the camera is set to a number higher than the film actually in the camera, the exposure system will let in less light because faster film requires less. The result will be a darker-than-normal image. Some films can be push processed, given extra development to compensate for intentional or accidental underexposure; see manufacturer's instructions. (See also Testing Your Film Speed, pp. 118–119.)

> *Exposure compensation dial not returned to zero.* If you used exposure compensation at a − 1 or − 2 setting and forgot to return the dial to zero, you will underexpose subsequent pictures.

> *Light entered the eyepiece,* influencing the built-in meter and causing it to underexpose, as when the camera is on a tripod and you are not looking through the eyepiece. When you use the camera in bright light without blocking the viewfinder with your eye, shade the eyepiece with your hand during the exposure or use the eyepiece blind designed for this purpose.

> *Shutter speed(s) too fast.*

℞ Dodging, p. 131 ▶ pp. 122–123

Many Pictures Too Light

Pictures that are too light are the result of the film being overexposed (too much light reaching the film). With slides, colors appear weak and washed out in direct relation to the amount of overexposure. Prints do not show this as clearly because corrections can be made when the negatives are printed, but a print from a considerably overexposed negative may look grainier or less sharply detailed than a print from a normally exposed negative. Compare the negative with a negative from a good print. An overexposed negative will be much darker.

> *Light too bright for the aperture or shutter speed selected.* In automatic operation, your selected aperture required a faster shutter speed (or your selected shutter speed required a smaller aperture) than your camera could provide. In manual operation, you set in too slow a shutter speed, too wide an aperture, or both.

> *Wrong film speed entered into film speed dial.* If the speed is set to a number lower than the actual film speed being used, the camera exposure system will overexpose. (See also Testing Your Film Speed, pp. 118–119.)

> *Exposure compensation dial not returned to zero.* If you used exposure compensation at a +1 or +2 setting on a previous picture and forgot to return the dial to zero, you will overexpose subsequent pictures. The same problem occurs if your camera has a backlight button that you forget to return to zero.

> *Camera set on "B"* causing overexposure.

> *Aperture failed to stop down.*

> *Shutter speed(s) too slow.*

℞ Burning-in, p. 130 ▶ pp. 122–123

Subject Very Dark Against Light Background

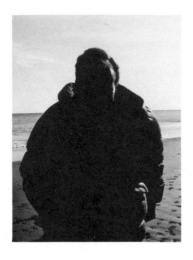

Your camera's exposure system averages the various brightnesses in a scene and exposes for that average. If your main subject is in front of a large, much brighter background, the camera tends to expose the background properly, because that is the predominant part of the scene. As a result, the main subject will be underexposed and too dark in the final photograph. This often happens when a person or other subject is photographed against a bright sky but can also occur, for example, when photographing indoors if a bright window or bright light fixtures are in the picture.

> *Auto-exposure system was influenced by a very bright background.* The camera exposed so that the background appears normal, resulting in the main subject being underexposed and too dark. If a relatively small, dark or medium-toned area is most important you can move close enough to meter just it or use exposure compensation to increase the exposure 1 or 2 stops (see exposure compensation, pp. 120–123) but in either case the entire scene will also be lighter.

> *Not enough light on the main subject.* If the most important subject is dark surrounded by a very light area and you want both properly exposed, use fill-in flash or reflectors to lighten the main subject.

> *Subject brightness range too great for the film.* Film, particularly color slide film, can record colors and details accurately only within a relatively narrow range of brightnesses. Often you have to choose the most important part of the scene, and expose properly for it, knowing that a less important part of the scene will be too light (or in some cases too dark) to show colors and details accurately.

℞ Dodging, p. 131

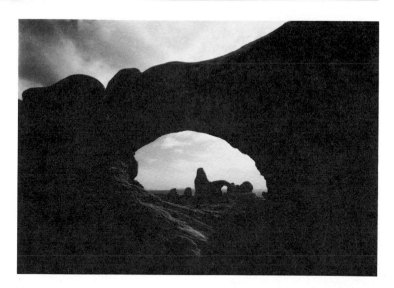

Underexposing a subject so it is very dark, even black, against a brighter background will silhouette the subject and make the outline of its shape more prominent than surface details. Above: arching rock formations are silhouetted against a bright sky. Below left: at a temple in Taiwan, boys look out of the shadows in one building at a brightly lit gate and courtyard. Below right: a potted plant is silhouetted against a bright window; bright highlights are reflected off the radiator top. To silhouette a subject deliberately while using automatic exposure, include a large, much brighter area in the background. Or if the bright area is relatively small, use exposure compensation to decrease the exposure 1 or 2 stops (see pp. 120–123).

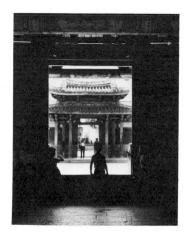

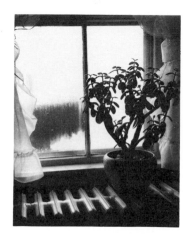

Subject Very Light Against Dark Background

When a relatively light or medium-toned subject is in front of a large, much darker background, the camera's automatic exposure system will be overly influenced by the darkness of the background. (See related problem on pp. 52–53.) This will cause the main subject to be overexposed and too light in the final photograph.

> *Auto-exposure system influenced by a very dark background.*
The auto-exposure system exposes for the average brightness of the scene that fills most of the viewfinder. To meter a relatively small, bright or medium-toned object against a large dark background, move close enough to the main subject to meter just it or use exposure compensation to decrease the exposure 1 or 2 stops (see exposure compensation, pp. 120–123). The entire scene will be darker, but the main subject will be properly exposed.

> *Subject brightness range too great for the film.* (See p. 52.)

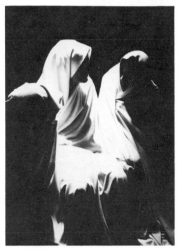 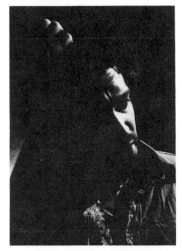

A very light subject stands out prominently against a dark background. Above left: the overhead lighting on this stage scene was very bright, with little light coming from other directions. As a result, the tops of the figures are very light, while their faces and other shaded areas are very dark. Above right: here, sidelighting was bright while little light came from above or the front. Below: brightly lit toes make an almost abstract, somewhat humorous, photograph.

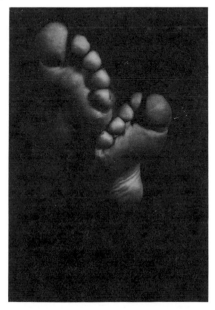

Problems at Night

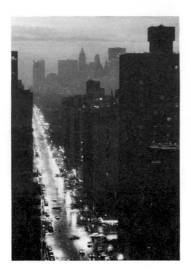

Unlike daytime, lighting at night usually consists of large, dark areas with scattered bright light sources and their small pools of illumination. The dark background plus bright light sources make results hard to predict because exact metering is more difficult than during the day. The best approach is to set your camera on automatic for one picture and then either bracket using exposure compensation (see pp. 118, 122) or switch to manual and try the settings listed on the facing page for additional exposures. After processing, you can choose the effect you like best.

> *Only bright lights show.* Street lights, neon signs, and other light sources are so much brighter than unlit areas that they will register on film long before unlit areas will. On automatic, very bright lights may cause the meter to assume that the overall scene is brighter than it actually is. If your goal is to have greater detail in the dark areas, the exposure should be increased: you could use a slower shutter speed (perhaps using the B setting that holds the shutter open until you close it), wider aperture, or faster film. With many street scenes dominated by bright, colorful lights, just having the lights show might be the most interesting approach.

> *Moving lights blurred* (for example, automobile headlights). Caused by the slow shutter speed, which is almost a necessity at night. The effect can be exaggerated to cause long light trails if a very slow shutter speed is used. To reduce the effect, use a faster shutter speed (using a faster film or a wider aperture would help to do this), move farther from the moving lights to reduce the effect, or wait for a period when no lights are moving.

> *Unexpected colors at night* are caused by reciprocity effect (color shifts at long shutter speeds) or by the mixed light sources often found at night from, for example, sodium vapor street lights plus neon signs and tungsten house lights.

Suggested Manual Exposures for Use Outdoors at Night

	Film Speeds							
	ASA 25-32 DIN 15-17		ASA 50-80 DIN 18-20		ASA 100-160 DIN 21-23		ASA 200-400 DIN 24-27	
Subjects	**Suggested Exposures**							
Streets	1/15	f/2	1/30	f/2	1/60	f/2	1/125	f/2
Night club and theatre districts, brightly lit	1/30	f/2	1/60	f/2	1/60	f/2.8	1/125	f/2.8
Neon and other lighted signs	1/30	f/2.8	1/60	f/2.8	1/60	f/4	1/60	f/5.6
Christmas lighting	1	f/2.8	1	f/4	1/2	f/4	1	f/4
Floodlighted buildings, fountains/ monuments	1/2	f/2	1/4	f/2	1/8	f/2	1/15	f/2
Skyline—distant lighted buildings	4	f/2	2	f/2	1	f/2	1	f/2.8
Skyline—10 min. after sunset	1/30	f/2.8	1/30	f/4	1/60	f/4	1/60	f/5.6
Fairs/amusement parks	1/8	f/2	1/15	f/2	1/30	f/2	1/60	f/2
Fireworks, on ground	1/30	f/2	1/30	f/2.8	1/60	f/2.8	1/60	f/4
Fireworks, in air	Keep shutter open for several bursts.							
		f/5.6		f/8		f/11		f/16
Fires/bonfires/ campfires	1/30	f/2	1/30	f/2.8	1/60	f/2.8	1/60	f/4
Lightning	Keep shutter open for several flashes.							
		f/4		f/5.6		f/8		f/11
Landscapes by moonlight			30 sec.	f/2	15	f/2	8	f/2
Snow scenes by moonlight	30 sec.	f/2	15	f/2	8	f/2	4	f/2
Full moon	1/125	f/8	1/125	f/11	1/125	f/16	1/250	f/16
Half moon	1/60	f/5.6	1/60	f/8	1/125	f/8	1/125	f/11

58

Snow Too Gray

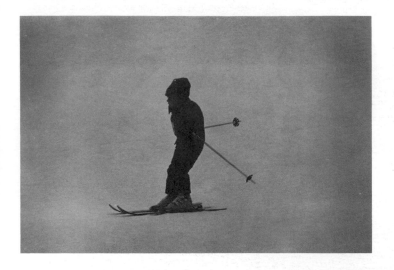

When your automatic exposure system meters a scene, it measures all the brightnesses in the scene from dark shadows to bright highlights, averages them, and then sets the camera's controls to record this average as a medium gray tone on the film. The system assumes that the tones in most scenes average out to a medium or middle gray. In fact, most scenes do average to middle gray, so that most of the time your automatic exposure system works well. However, even though the system always exposes for middle gray, there are some scenes in which the average of the tones is not middle gray. Snow-covered scenes, for example, usually have an average tone lighter than middle gray. The result (unless you override the automatic exposure system) is an underexposed photograph in which the snow looks gray and muddy.

> *Overall tone of the scene is lighter than middle gray.* Use exposure compensation (see pp. 120–123) to increase the exposure about 1 stop. The scene will be lightened so the snow appears whiter.

Fog Too Gray

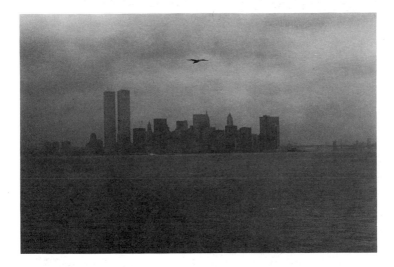

Like snow-covered scenes, those in heavy fog also have an overall average tone lighter than the middle gray for which the camera's auto-exposure system exposes. The result is likely to be photographs that appear much darker than you remember the scene. The soft, white fog becomes dark and heavy, more like a storm, so that the mood of the scene may be lost.

> *Overall tone is lighter than middle gray.* Use exposure compensation (see pp. 120–123) to increase the exposure about 1 stop to lighten the picture.

Contrast Very Low

Pictures with low contrast look dull with not enough difference between light and dark areas. Colors lack brilliance and the overall image looks flat, much like looking at the scene through a very dirty window.

> *Condensation or dirt on the lens* tends to scatter light entering the lens. This randomly scattered light strikes all portions of the film, flattening out the exposure by lightening the shadows and darkening the highlights. Clean the lens when dust builds up on it. Better still, keep the lens protected from dirt, dust, and water. Use a lens hood, especially in the rain, and keep the camera in its case when not being used.

> *Lens flare.* When the camera is pointed toward a bright light source such as the sun, the light may hit the front surface of the lens and reflect off its interior walls. This light is randomly scattered over the film, reducing overall contrast. A lens hood helps prevent this problem. (See pp. 62–63.)

> *Foggy day.* Objects at a distance have lowered contrast on a foggy day. If no significant part of the scene is near the camera, the overall picture may look dulled.

▶ pp. 62–63

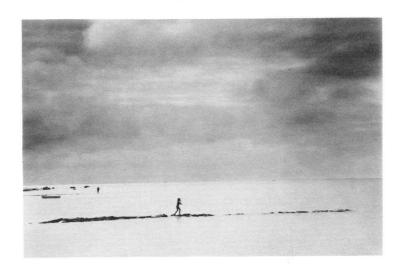

A foggy day may lower contrast between light and dark areas and make colors dull, but this fogginess can in itself be the subject of the picture. Above: a few small, dark forms are sketched in brief across this beach scene. Below: the tombstone nearest the camera is the only one with significant detail. All the others fade into a foggy and out-of-focus background.

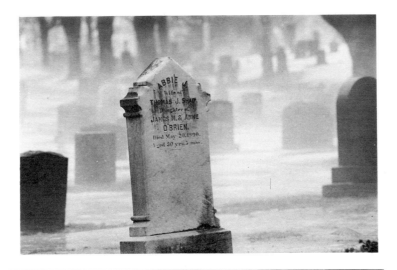

Lens Flare

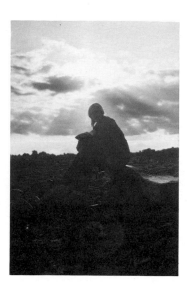

If you have ever looked through a dirty window toward a very bright sun, you may have noticed how the scene appeared full of light reflections and glare. This is the same effect that lens flare has on a photographic image. If light strikes the lens's surface directly, it bounces off the walls of the lens barrel and randomly scatters over the film. Occasionally, the lens flare will appear as streaks of light or a ray of light across the image similar to a shaft of light through broken clouds. There may also be one or more images of the circular lens diaphragm. A more frequent effect is simply lowered image contrast.

> *Camera pointed directly toward a bright light source such as the sun.* Very bright light entering the lens increases the likelihood of lens flare. Even when pointed in the general direction of a bright light source, light may flare. Use a lens hood to keep stray light from entering the lens. Sometimes you can position the camera so that the lens is shaded from the bright light source, such as in a shadow of a tree, overhang, or other shaded area.

> *Too many or poorly made filters.* The more air-to-glass surfaces there are, the more likely you are to encounter lens flare. Never use more filters than required by the situation. Good quality filters, like good quality lenses, have an optical coating that reduces lens flare. Using a poor quality, uncoated filter increases the chances of flare problems occurring.

▶ pp. 60–61

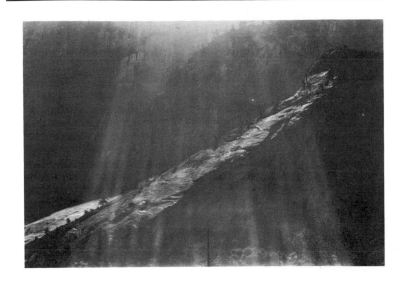

Shooting directly at a bright source of light almost always causes flare—
and sometimes an interesting addition to a scene. Above: flare combines
with bright streaks of sunlight in the atmosphere. Below: the sun's rays
passing through the lens's optical elements created bright streamers
of light in the picture.

Clouds Don't Stand Out

When you photograph a landscape or other scene with large, billowing clouds, you may be disappointed by the resulting prints or slides. The sky appears lighter than you remembered and the clouds that made the scene so dramatic and beautiful either are very faint or have disappeared altogether. Film is very sensitive to the ultraviolet and blue rays of the sky; the result may be overexposure and a sky that looks too light. In addition, the sky is often so bright in relation to the foreground that it is overexposed in pictures where the foreground is properly exposed.

> *A polarizing filter* can be used with either color or black-and-white film and in combination with other filters. It reduces reflections from minute particles in the atmosphere and works best when used at an angle of 90° to the sun (when the sun is to your right or left). Place the filter on your lens, rotate it until you get the desired effect, then expose with the filter in that position.

> *A warm-toned filter* can be used with black-and-white film. A yellow (8) filter darkens the sky to a normal tone, a deep yellow (15) filter makes it slightly darker, and a red (25) or deep red (29) has the most effect of all. These filters work best when the sky is actually blue. Haze, smog, and fog reduce their effect.

> *A UV ultraviolet or 1A polarizing filter* can be used with either color or black-and-white film to penetrate bluish haze and darken the sky somewhat.

℞ Burning-in, p. 130

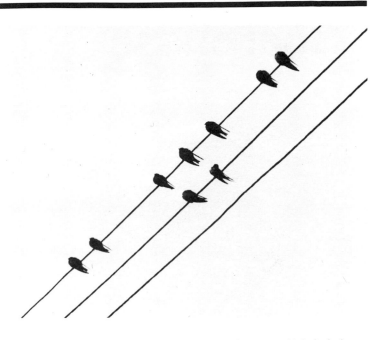

A sky without clouds can be a plain background against which dark shapes stand out clearly. Above: birds have arranged themselves on wires like notes on a music stave. Below: the shapes of gondolas in Venice are graphically outlined against the bright sky and water.

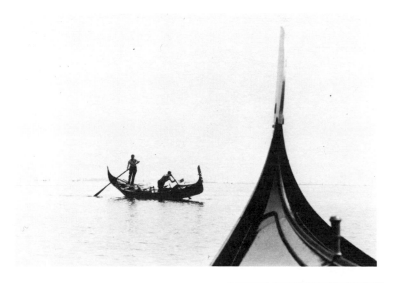

5 Sharpness

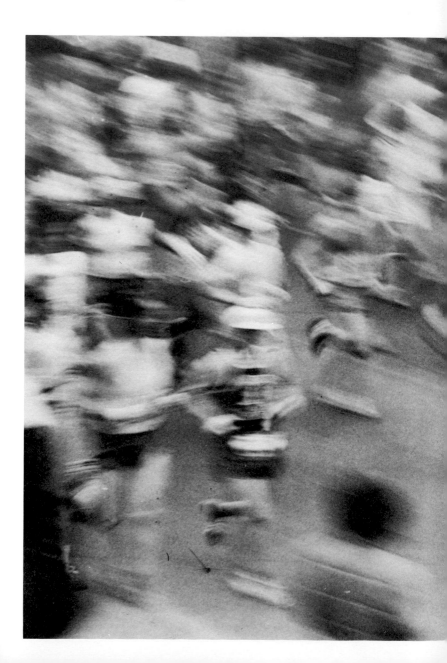

Image All Blurred
Moving Subjects Blurred
Foreground Sharp/Background Not

Background Sharp/Foreground Not
Wrong Part (or None) Sharp
Image Fuzzy

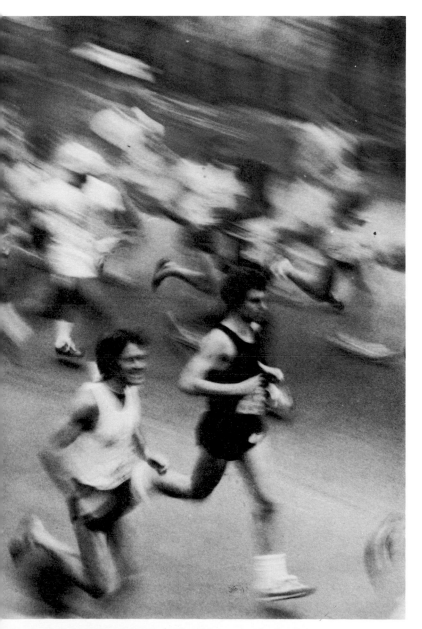

Image All Blurred

You can often identify the cause of an unsharp image by a distinguishing feature. An image that is blurred throughout is usually the result of camera movement during the exposure. Its telltale sign is a pattern to the blur rather than being just fuzzy. Bright areas in the picture will be streaked and will appear to be "painted" across the film's surface much like the pattern of a moving flashlight beam as you sweep it across a wall.

> *Shutter speed too slow for focal length of lens.* The rule of thumb is to use a shutter speed no slower than your lens's focal length. In other words, no slower than 1/30 sec with a 28mm lens, 1/60 sec with a 50mm lens, 1/250 sec with a 200mm lens, and so on. If your camera's exposure system is aperture-priority, choose a large enough aperture to give you the shutter speed you need.

> *Body movement during exposure.* Brace yourself and push the shutter release slowly when taking a picture.

> *The overall light level is too low,* causing your camera (aperture-priority or fully automatic) to use its slower shutter speeds. If opening up your aperture doesn't raise your shutter speed enough, you can use a faster film (requires less light for the same exposure), a flash unit to light the scene, or a tripod.

▶ pp. 78–79

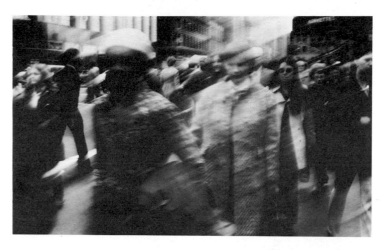

Above: a busy city street appears even more active because of the blurs and streaks caused when the photographer deliberately moved the camera during the exposure. Below: here the photographer panned the camera—moved it in the same direction as a moving subject. The stationary background is extremely blurred, but the subject is relatively sharp because the camera more or less kept up with his movement. Notice that his feet, which are moving fast, show the most blur.

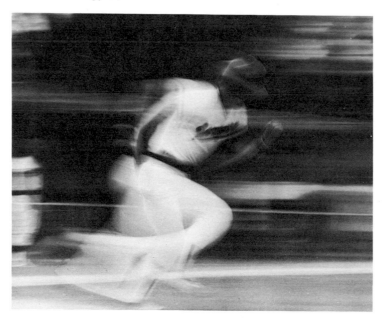

Moving Subjects Blurred

When everything in a photograph is sharp except a moving object, which is blurred, the cause is always too slow a shutter speed. In this photograph everything is sharp but the moving subject. The shutter speed used was fast enough to eliminate camera movement but not fast enough to freeze the movement of the subject.

The shutter speed required to freeze motion depends on the speed and direction of the subject, its distance from the camera, and the focal length of your lens. Some of the ways to increase your ability to freeze motion are:

> *Increase your shutter speed* by selecting a faster speed (shutter-priority cameras) or a larger aperture (aperture-priority cameras). You can also get higher shutter speeds by using faster film or a faster lens (one that opens to a wider maximum aperture).

> *Use a shorter focal length lens or move farther away* from the moving subject; either will reduce the amount of blur. The subject, however, will be smaller in the picture.

> *Capture the peak of action* when motion is momentarily arrested, such as with a diver at the peak of the spring from the board before the downward plunge begins.

> *Change the angle* from which you are shooting; objects moving toward or away from the camera record more sharply than ones moving at the same speed parallel to the camera.

> *Use flash*. Because electronic flash has a burst of light faster than the fastest shutter speed, it can successfully freeze action that cannot be stopped in other ways.

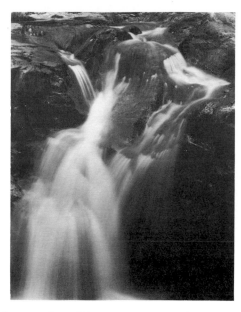

A slow shutter speed can blur a moving subject to convey a visual sense of
speed and motion. Above: the bright highlights on water rushing down
a mountain stream merge into white streaks during a ½-sec exposure.
Below: the camera was on a tripod to photograph the old mill building,
which is sharp in the background. The two bikers were moving fast enough
to blur even during a relatively fast 1/125-sec exposure.

Foreground Sharp/ Background Not

One of the most difficult things for photographers to remember is that the scene that is three-dimensional when viewed in real life will be compressed into a two-dimensional print or slide in which all areas become equally important. Your concentration on the main subject may be so intense that you forget to watch the background and think about how it will be rendered. The result may be that the main subject will be in focus but the background, which is also important, will be soft and less distinct.

> *Use a smaller aperture.* The smaller the aperture, the greater the depth of field (the depth in a scene from foreground to background that will be sharp). With an aperture-priority camera, select a smaller aperture. With a shutter-priority camera you can reduce your aperture by using a slower shutter speed.

> *Use a faster film* (one with a higher film speed, ASA, DIN, or ISO). A film with more speed requires less light for the exposure and lets you use a smaller aperture.

> *Move farther back.* The farther the camera is from the subject the greater the depth of field.

> *Use a shorter focal length lens.* A short lens has greater depth of field than does a long one.

> *Check your depth of field before taking the picture.* Lenses (except for some zooms) have a depth-of-field scale engraved on the lens barrel that allows you to predict depth of field at various apertures and focusing distances. Some cameras have a depth-of-field preview button that stops down the lens to the taking aperture so you can get a visual preview of the depth of field.

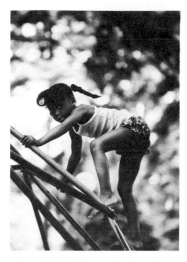

Above left: deliberately having the background out of focus is one way to make a distracting background less conspicuous. Here bright sky and dark leaves merge into a blurred pattern against which the girl stands out sharply. Above right: only a very shallow depth is sharp in close-ups. This is useful when working in nature because the out-of-focus background, which often you are not interested in, almost disappears into a soft blur against which the sharp main subject is prominent. Below: occasionally an out-of-focus background calls attention to itself. The play between sharp ice cream cone and out-of-focus server makes the picture more interesting than if both were sharp.

Background Sharp/ Foreground Not

There is always a tendency to focus the camera on the object in the scene that has most caught your eye. For example, in a scene that includes distant objects, the most interesting aspect might be something in the far background. If you focus on something far away, it will be sharp, but you may well have a blurred and out-of-focus foreground. If you focus somewhat closer to the camera, you may be able to get both the foreground and background in focus at the same time.

> *Focus for maximum depth of field.* Instead of using the view-finder to focus on a distant subject, use the lens barrel engraving. Align the ∞ mark on the distance scale opposite the point on the depth-of-field scale that shows the aperture you are using. Note what distance falls next to the same aperture mark on the other side of the depth-of-field scale. Everything between that distance and ∞ will be in focus in your picture.

> *Do not focus closer than minimum focusing distance.* Even when focused for maximum depth of field, there is usually a zone near the camera where objects cannot be brought into focus.

> *Use a smaller aperture* to increase your depth of field. (For other ways to increase your depth of field, see pp. 72–73.)

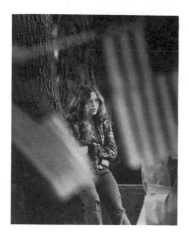

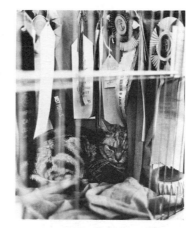

Because the eye tends to look first at the sharpest part of a photograph, an out-of-focus foreground is one way to get the eye past a less important foreground to a more important subject beyond. Above left: a pensive girl is framed by her out-of-focus companions in the foreground. Above right: a pensive cat waits out a cat show. The bars of the cage are less conspicuous out of focus than they would be if sharp. Right: the woman's face, sharply focused, was more important to the photographer than the back of the woman's head.

Wrong Part (or None) Sharp

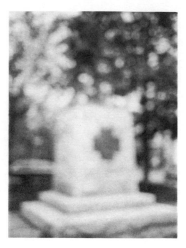

Your photograph will be completely out of focus if it is not sharp anyplace, and if objects appear to have a diffuse halo, as if you were looking at them through a fog. When the focus is slightly off, the main subject may be soft while objects closer to or farther from the camera will appear sharp. At very wide apertures (such as f/1.8 or f/2), or with very long focal length lenses (such as 400mm or longer), or very close camera-to-subject distances (3 feet or less), the lens's depth of field is very shallow and focusing becomes critical.

> *Improper focus.* When focusing in dim light the viewfinder screen may be hard to see. If you have a split-image rangefinder, try focusing on a part of the subject that has a sharp vertical edge. If this isn't possible, focus using the distance on the lens barrel after measuring or estimating the camera-to-subject distance. Persistent difficulty in focusing may be caused by inability of the eye to focus the viewfinder image, a common problem for far-sighted people. Some cameras can be fitted with an eyepiece correction lens that will make focusing easier.

> *Camera used too close to subject.* If the main subject is very close to the camera and is out of focus but the background is sharp, you may have been closer than the lens's minimum focusing distance.

> *Insufficient depth of field.* If part of the scene you wanted to be sharp is but other important parts aren't, then you had insufficient depth of field. (See p. 72 for ways to increase depth of field.)

> *Pressure plate out of alignment.* If you have a recurring problem with a similar area in each picture being out of focus, it may be that your camera's pressure plate, which holds the film flat, is out of alignment. Have your camera checked at a repair shop.

Above: true, the dog is completely out of focus. Yet, a dog owner might appreciate this snout-close view reminiscent of those Sunday mornings when the dog wanted to go out, even though the owner was still in bed. Below: the photographer did the opposite of what most would have done by focusing on the bars in the zoo's aviary and letting the bird go out of focus.

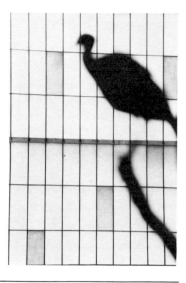

Image Fuzzy

Even with your camera properly focused and held absolutely steady, you can still get an image that lacks overall sharpness. In these cases there is no pattern to the image blur but the picture suffers from an overall lack of crisp detail.

> *Condensation, dirt, fingerprints, and so forth, on front or rear lens surfaces.* A very dirty lens will give an overall softness to an image. Avoid getting your lens dirty in the first place, but if necessary clean it before using.

> *Fungus inside lens.* If lenses are stored in damp, humid conditions, fungus may grow on the inside lens surfaces. You can see the fungus if you open the lens to its widest aperture and look through it at a bright light source. The fungus will appear as spots or specks inside the lens. Fungus can be removed by a qualified service person.

> *Poor quality lens.* All lenses have aberrations that soften the image quality. Many of these can be reduced by design, manufacturing and quality control, and in quality lenses this is done. With poor quality lenses, defects become more apparent, especially when a photograph is greatly enlarged.

> *Optical accessories such as teleconverters or filters* may cause images to be somewhat softer than normal.

▶ pp. 68–69

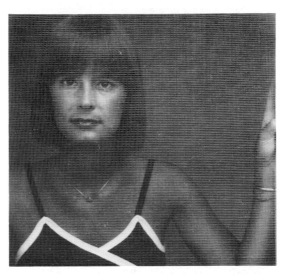

Any substance that comes between the scene you are photographing and the lens will add its own texture to a picture. Above: shooting through a screen door overlaid a cross-hatch pattern on the subject. Textured overlays and textured papers were very popular at one time as a way of adding surface interest to photographs. Below: a clear filter smeared with petroleum jelly created the halos around the light areas. A single-lens reflex camera lets you view the scene through the lens and filter combination, so it is easy to see the effect created by devices of this type and to manipulate them as you wish.

6 Flash

Only Part of Image Exposed
Flash Image "Ghosts"
Reflections of Flash Light
Eyeglass Reflections/Redeye
Prominent Shadows
Image Lacks Sense of Texture
or Volume

Subject Too Light
Subject Too Dark
Part Right/Part Too Light
Part Right/Part Too Dark
Center Right/Edges Dark
Too Dark/Too Light Out Doors
or in Large Room

Only Part of Image Exposed

The burst of light from an electronic flash is brief—1/1000 sec and often less—and for a proper exposure it must be synchronized with the moment that the camera shutter is fully open. If the flash and camera do not synch (pronounced sink) correctly, then only part of the film frame will be exposed. The other part of the frame will be unexposed and appear black in a slide or print, clear in a negative. (A partial exposure may register if the existing light on the scene is very bright.)

> *Flash not synchronized with shutter,* leaving the film partially covered when the flash goes off. Some automatic flash units automatically set your shutter so it synchs with the firing of the flash; you just attach the unit to the camera. With other flash units you must manually set the shutter to the correct speed for flash. Often the correct flash setting is indicated by an "x" (100x, for example), but check your owner's manual to be sure.

Rx Cropping, pp. 128–129

Flash Image "Ghosts"

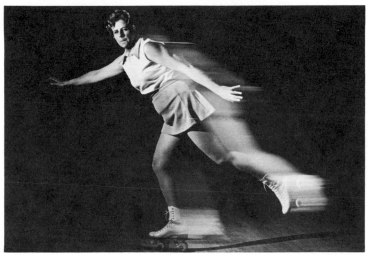

If you get flash "ghosts," a sharp image next to a blurred image of the subject, the flash was probably used in relatively strong available light, such as with a spotlit subject or in a room lit by several bright lamps. The flash exposed the sharp image, but the existing light was bright enough to register a secondary image on the film during the time that the shutter was open.

> *Bright existing light.* The brighter the light existing in a scene, the more likely you are to have flash ghosts. Light sources themselves, such as Christmas tree lights, are most likely to ghost.

> *Shutter set at a slow speed.* Flash can be used either at the recommended shutter speed (usually 1/60 to 1/125 sec) or at any slower speed. Slow speeds, however, increase the chance that the existing light will be bright enough to create a secondary image.

> *Fast film used.* A fast film (one with a high film speed rating) is useful with flash because the flash will adequately illuminate objects at a farther distance than it can with a slow film. However, existing light is more likely to be bright enough to register on fast film than on slow film.

> *Fast moving subject.* All of the above conditions are more likely to lead to flash ghosting if the subject is moving rapidly than if relatively still.

Reflections of Flash Light

A reflection of the flash light from a mirror, window, or other shiny surface appears in a photograph as a white area, one that can be quite large. This results from the flash being perpendicular (at a 90° angle) to the shiny surface, so its light reflects straight back toward the camera. The reflection is too fast to be noticeable while you are shooting, but will be visible in the photograph.

Any flat, smooth surface—such as a mirror, glass window or display case, wood paneling, metal or plastic—can reflect enough light to be distracting. If such a surface is in the background (or is part of the subject itself), see that the light from the flash does not strike the shiny surface at a 90° (right) angle. This way the light will reflect away from the camera, instead of back into the lens. To do this:

> *Move the camera and flash to one side.*

> *Use the flash off camera.* An electrical wire connection called a synch cord is required. Make sure your camera and flash have outlets for such a connection.

> *Use bounce flash.* Some flash units allow you to swivel the flash head so the light bounces off the ceiling or walls before hitting the subject. This softer, less direct light should reduce reflections from shiny surfaces.

> *Move the subject.*

Eyeglass Reflections/Redeye

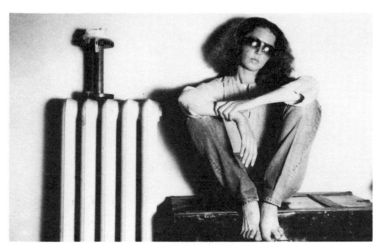

When the flash unit and camera lens are very close together (commonly when the flash is mounted on top of the camera), reflections from a person's eyeglasses can show an image of the flash light if the person is looking directly at the camera during the exposure. Here the flash was pointed into an umbrella reflector, which was positioned very close to the camera. Light can also be reflected from the blood-rich retina of the eye, causing it to appear in a color photograph, the so-called redeye effect. Children and animals are particularly likely to show redeye.

To prevent flash light from reflecting directly back at the camera from eyeglasses or eyes:

> *Use bounce flash.*

> *Have the subject look slightly away from the flash.*

> *Use the flash off camera.*

If you want a straight-on flash portrait:

> *Turn on the room lights.* In very dim light the pupils open up, increasing the likelihood of redeye. With the room lights on, the pupils will close down, reducing the redeye effect.

> *Tilt eyeglasses slightly.* The person can still look straight at the camera but the chance of eyeglass reflections is decreased.

Prominent Shadows

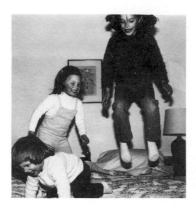 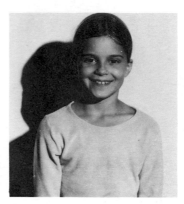

Light from direct flash tends to cast very dark, distinct shadows. If there is a surface, particularly a light colored one, close behind the main subject on which these shadows can fall, they will appear in the photograph. Shadows are even more noticeable if the flash is used off camera (see above, right).

> *Move subject away from wall or other surface* so that the shadows fall outside of the picture area.

> *Use bounce flash* because this diffuses the light and reduces the intensity of shadows cast by objects in the scene.

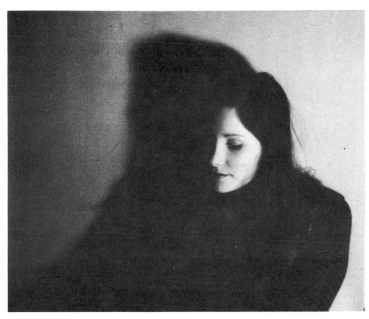

Prominent shadows can add interest to a picture. Above: the light tones of the woman's face stand out against her dark hair and clothing and the dark shadow on the wall. The light was placed somewhat below and to the right of her face. Below: the bright wall reflection and hard, dark shadows add to the mood of this picture of rock fans. The light was placed to the far left.

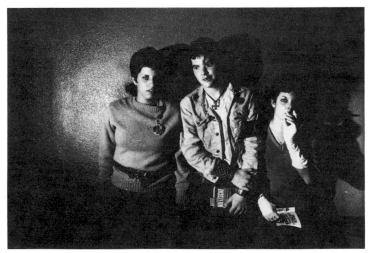

Subject Lacks Sense of Texture or Volume

Most automatic SLR's have a bracket on top of the camera to which a flash can be attached. This position aims the flash directly at the subject, reducing the sense of modeling and texture that side lighting gives. The result is an almost shadowless exposure over the entire surface of the subject, making it appear relatively textureless, flat, and two-dimensional. Generally, this is not the most flattering lighting for portraits, with one exception: if your subject is concerned about facial wrinkles, direct light from flash on camera will minimize them.

> *Use flash off camera.* Increasing the angle between the flash and camera increases the light's modeling effect, adding form and depth to the subject.

> *Use flash bounced from one side or from above.* This casts a soft, diffused light on the subject from an angle, enhancing forms without creating hard shadows.

The two-dimensional look of flash-on-camera lighting can be used to advantage, particularly outdoors at night or in very large rooms where the background is too far away for the flash to illuminate it. The flash-lit subjects shown here look almost like cardboard cutouts, brightly lit and shadowless against the dark background.

Subject Too Light

Images that are too light are characterized by washed out looking colors, loss of details in the highlight areas, and an overall weak appearance. This is caused by too much light reaching the subject and then being reflected back to overexpose the film.

> *Wrong film speed entered into flash unit calculator dial.* Flash exposures are based on the speed of the film being used (as well as the distance of the subject from the flash). If you set the flash for a film speed lower than the film in the camera, the flash will calculate an increased exposure for what it thinks is a less sensitive film.

> *Wrong aperture set on lens.* Flash units require a specific aperture for a given distance range and if you set the lens at a wider aperture, pictures will be overexposed.

> *Subject too close to camera.* Automatic flash units are designed to work at a specific range of distances from the subject. If you are closer than the minimum distance, the picture will be overexposed and too light.

℞ Burning-in, p. 130 ▶ pp. 54–55, 92–93

Subject Too Dark

Flash pictures that are too dark will have little or no detail in shadow areas and an overall dark, dense appearance. This is caused by not enough light reaching the subject, thus underexposing the film.

> *Wrong film speed entered into flash unit.* If the film speed entered on the dial is higher than the speed of the film in the camera, the exposure will be calculated by the flash to give less light than the film requires.

> *Wrong aperture set on lens.* If the aperture set on the lens is smaller than the aperture at which the flash is designed to work, the picture will be too dark.

> *Subject too far from camera.* Automatic flash units are designed to give good exposures within a given range. If the subject is farther from the camera than the maximum range, the picture will be too dark.

> *Flash bounced* but with automatic flash sensor pointed at the reflecting surface instead of at the subject. Or flash bounced in non-automatic operation without extra exposure added; about 1 stop additional exposure is required for average bounce situations. Or flash bounced from a surface too far away or too dark to reflect enough light.

Rx Dodging, p. 131 ▶ pp. 52–53, 94–95

Part Right/Part Too Light

If a scene includes objects at different distances, objects that are closer to the flash will be lighter than those that are farther away. If your flash exposure is set properly (either automatically or in manual mode) for objects that are relatively far from the camera, those that are much closer will be overexposed and too light.

> *All of the important subjects are not the same distance from the flash.* If you are photographing a group of people, for instance, and some are closer to the camera than others, those who are closer may appear too light and overexposed. To reduce the problem align all the subjects more or less at the same distance from the camera, or use bounce flash to diffuse the light over a wider area.

> *Part of the scene is closer than the minimum distance at which the flash should be used.*

> *Main subject is off center.* If the main subject is close to the camera, but off center, the sensing cell may compute the exposure for a more distant subject, perhaps a wall, leaving the main subject overexposed and too light. Many sensors read only the central portion of a scene, about a 15°–20° angle.

℞ Burning-in, p. 130 ▶ p. 90

An overexposed and too light part of a picture can be a strong and prominent shape, especially if it is against a dark background. Above: hands that were closer to the camera than the rest of the subjects add to the chaos of this back-of-the-bus crowd. Below: massively overexposed against a dark night scene outdoors, a man and the smoke from his cigarette become a strange poolside sight.

Part Right/Part Too Dark

The farther that objects are from a flash, the dimmer the light that reaches them. If your exposure is correct for objects at a given distance—for example, 10 ft—those that are more than half again that distance (in this example, 15 ft or farther) will be darker in the photograph. Those that are twice as far away (in this case, 20 ft) will definitely look too dark.

> *All of the important subjects are not at the same distance from the flash.* If all of the subjects of importance are the same distance from the flash they will all be exposed equally. If some are farther away than others, those will be darker. Try arranging your subjects or position your camera so that all subjects are equally distant from the flash. Bounce flash also helps because it tends to spread the light more evenly.

> *Main subject is off center.* The automatic sensor on some flash units is designed to read and compute the exposure based on an area smaller than the entire image area. Your main subject may be too dark if it is off center and farther away than a subject of less importance that is in a central position.

> *Part of the scene is farther away than the maximum recommended distance for the flash.*

℞ Dodging, p. 131 ▶ p. 91

Because objects that are far from a flash are darker than those that are nearby, you can take advantage of this to isolate your subject from its background. This is particularly easy to do outdoors at night, as in these parade scenes.

Center Right/Edges Dark

If your photograph is properly exposed at the center but the edges and corners did not receive enough light, you may have used a wide-angle lens on your camera and a flash that did not put out a broad enough beam of light to illuminate the entire scene. The beam of light from a flash covers at least the same area seen by a normal-focal-length 50mm lens. Many flash units illuminate a wider angle of view, enough to cover the area seen by a 35mm lens or even a 28mm lens. Using a lens with a focal length longer than 50mm creates no problem; long lenses see a narrower part of a scene. But when a wide-angle lens is used with a normal flash unit, the lens will see a wider angle of view than the flash covers and part of the scene won't be lit.

> *Use an accessory diffuser over the flash* to spread the flash's beam of light.

> *Use bounce flash* because it tends to spread the flash's beam of light over a wider area.

> *Change lens to longer focal length* because its narrower angle of coverage will be covered by the flash.

Rx Cropping, pp. 128–129 ▶ pp. 102–103

Too Dark/Too Light at Night or in Large Room

Flash units are designed to work well in the situations in which flash is most often used. Because most flash units are used indoors in average-sized rooms, exposures are calculated on the assumption that some light will be reflected off nearby walls and ceilings, increasing the total amount of light reaching the subject as well as illuminating some of the background. When this same flash unit is used outdoors at night or in a very large room, the flash may produce an underexposed and too dark (or with some units, an overexposed and too light) photograph.

> *Outdoor pictures at night tend to be too dark.* Your flash probably depends on reflective surfaces nearby to add to the subject's illumination. If you are outdoors or in a very large room, like a gymnasium, set the camera's exposure compensation dial to + 1 (or in manual operation, open the aperture 1 stop more than recommended by your flash calculator). This will allow extra light to reach the film.

> *Bounce flash pictures too dark.* The light may have been bounced off a surface too far away or too dark to reflect enough light.

> *Outdoor pictures at night tend to be too light* (especially in automatic operation). The sensor is reading the entire scene—the dark background as well as the subject, and overexposing the picture as a result (similar problem as on pp. 52–53). In automatic operation, set the camera's exposure compensation dial to − 1 to reduce the amount of light reaching the film. You are less likely to have this problem in manual operation.

℞ Burning-in and dodging, pp. 130–131

7 Miscellaneous Problems

Only Part Exposed

Uneven Exposure Across Frame

Corners Dark

Spots on Picture

Hair (or Other Marks) on Picture

Lines (Scratches) on Film

Torn Sprocket Holes

Overlapping Images

Static Marks

Light Streaked or Fogged

Only Part Exposed

When part of your photograph appears normal but the image is missing from another part of it, something blocked the light from reaching that portion of the film. The blocked area will appear clear on a negative and black on a slide or print.

> *Obstruction in front of camera.* The edges of a strap or other obstruction in front of the lens when the picture was taken will appear out of focus and fuzzy.

Uneven Exposure Across Frame

When you depress the shutter release on your camera, the viewing mirror swings up and the focal plane shutter moves across the film (horizontally or vertically depending on its design) to expose it. If movement of either the shutter or mirror is impeded, the film will not receive an equal amount of light across its surface and part of the final picture will be darker than the rest.

> *Mirror moves sluggishly.* If the mirror is slow in moving out of the way, the final picture will have a darker bottom which gradually fades into a lighter top.

> *Shutter movement is irregular.* Focal plane shutters move either horizontally across the long dimension of the film or vertically across the short dimension. If the shutter moves irregularly, you will have lighter and darker strips across the film in the direction the shutter travels. The most likely result is darker bottom or sides in the final photograph.

> *Shutter bounce.* If the mechanism that operates the shutter becomes weak, the shutter curtain can bounce back slightly at the end of the exposure. This will leave a lighter strip at one edge of the film.

Corners Dark

If the corners of a print or slide are dark (vignetted), light was blocked by filters or a lens hood. In extreme cases, the image can be circular inside the rectangle of the film frame.

> *Too many filters*. When more than one lens attachment is screwed on to the front of the lens, the outer ones may cut into the lens's angle of view. Check the corners of the viewfinder image if you use more than one filter or a filter plus a lens hood.

> *Wrong size lens hood*. The lens's angle of view can be cropped by a lens hood that is too small. The shorter the focal length of the lens, the shallower and wider the lens hood must be. If you use lenses of different focal lengths, you will probably need different lens hoods for them. When buying (and using) a lens hood, make sure it is designated as suitable for your lens's focal length.

℞ Cropping, pp. 128–129 ▶ p. 97

Above: the ultimate vignette, a circular image created by attaching a fisheye lens attachment to the front of an ordinary lens. Below: a partial vignette repeats the curves of the rocks. The vignette was created by using a lens hood that was too narrow for the lens on the camera.

Spots on Picture

Dust on film during printing

Dust on film before processing

*White spots on prints, black spots on slides, and clear areas on negatives
indicate that something kept the light from reaching the film in those areas.*

> *Dust on film.* These spots are usually small and sharp-edged.
They are caused by dust on the negative during printing (white
spots on print) or by dust or dirt getting on film before processing
(clear or black spots). Keep film cassettes away from dust and
dirt, preferably in their individual protective containers. Keep dust
out of the inside of the camera, where it can easily fall on the film.

> *Dust on lens.* Dust spots on the lens surface of an ultra wide-
angle lens may appear as diffused, soft-edged spots on the photo-
graph. Keep your lens covered when stored and clean it when
necessary.

> *Raindrops on lens.* These can leave large, soft diffuse spots on
the photograph. Use a lens hood to protect the lens when photo-
graphing in the rain.

> *Flash outdoors in rain or snow.* When the flash is fired, raindrops
or snowflakes in the air will be brightly illuminated if they are
near the camera and will appear as white spots in the photograph.

℞ Spotting, p. 127 ▶ p. 114

Hair (or Other Marks) on Picture

Any object inside the camera back that blocks light from reaching the film will leave a sharp image on the photograph. Sometimes the kind of object it is can be identified from the mark it leaves on the film.

> *Hair inside camera.* Occasionally when film is loaded into the camera, a hair may fall in the shutter area. This will appear as a dark hairline in the print or slide and as a clear hairline on the negative.

> *Film bits inside camera.* Small pieces of film occasionally break off and lodge inside the camera. These will appear as irregular shaped dark spots on a print or slide and clear areas on the negative.

℞ Spotting, p. 127 ▶ p. 114

Lines (Scratches) on Film

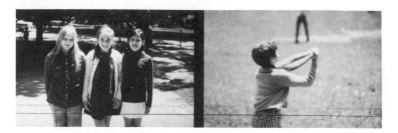

Lines running across the film's long dimension often indicate that the film was scratched while being wound through the camera.

> *Dirt or rough spots on pressure plate.* If film is scratched on the shiny backing side (the emulsion side is slightly dull) the cause may be dirt on the pressure plate that holds the film flat. Open the camera back and check the plate mounted on the part that swings open. Clean gently with a lens brush or with lens cleaning tissue.

> *Dirt on film cassette felt.* The film cassette has a felt slit through which the film leaves the cassette. Keep the felt clean by carrying the cassette in its protective container until loaded into the camera.

> *Careless handling of film or slides.* Sliding a strip film or a slide against an abrasive surface can also cause scratches. Handle film and slides by their edges and keep in protective view sheets or other safe storage containers.

℞ Spotting, p. 127 ▶ p. 114

Torn Sprocket Holes

There are small holes along each side of the film that engage the sprockets that advance the film. If excessive force is used to advance or rewind the film, the sprockets will tear through the relatively weak borders around the holes in the film.

> *Failure to push rewind lever before rewinding film.* The rewind lever releases the sprockets that advance the film, so that an exposed roll of film can be rewound into its cassette. If you try to rewind without depressing the rewind mechanism, the film will be caught in the sprockets and be torn if undue pressure is used.

> *Processing error.* Most commercial film processing is mechanized and occasionally film is damaged during this operation.

> *Forcing film to advance* in an attempt to get one more exposure when the end of the roll has been reached.

► p. 114

Overlapping Images

Normally exposed film has each frame separated from those next to it by a small space of unexposed film (clear on a negative, black on a slide). With slides, a cut is made in this space to separate the images for mounting. With negatives, the small spaces allow each negative to be printed separately. The film has been double exposed if you get more than one scene recorded on a frame. A whole roll may be double exposed. Occasionally a few individual frames will overlap so that part of one image is superimposed on one of those next to it.

> *Film run through the camera twice.* Rewind your film entirely into its cassette so that none of the film hangs out of the cassette: this eliminates the possibility of confusing exposed and unexposed rolls and double exposing the film. Always complete rewinding once you start so you won't accidentally start shooting again on a partially rewound roll.

> *Rewind button inadvertently pushed.* Pushing this button disengages the sprocket wheel used to advance the film. Then when you move the film advance lever it will cock the shutter but will not advance the film. This is one way to make a double exposure intentionally.

> *Film not caught on take-up spool sprockets.* This is usually the cause if the overlapping images are the first few on the roll. Too much slack left in the film when loading it may cause the first few frames to overlap.

> *Film advance mechanism not working properly.* If images are consistently overlapped or unevenly spaced, have the camera checked by a competent service person.

℞ Cropping, pp. 128–129

Right: to make multiple exposures of a dancer, the photographer set up a camera on a tripod, opened the shutter, then made several flash exposures (tripping the flash manually). The room had no strong illumination except for the flash, so that only the flash exposures registered on the film. Below: the photographer opened the shutter at various times and for different lengths of time to make this airport scene of multiple exposures and streaked lights of moving objects.

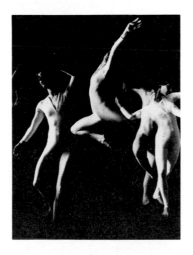

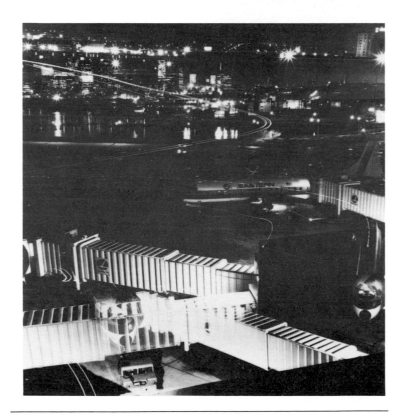

Static Marks

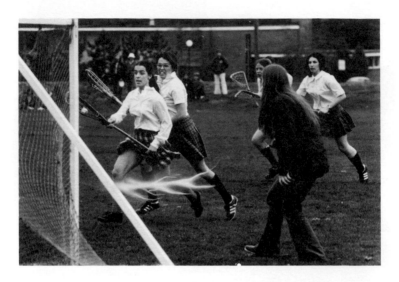

In dry weather, static electricity builds up when film is moved quickly across the interior camera surfaces. This is much like dragging your feet across a carpet and then touching an object to generate a shock or small spark. In the camera, the discharge of electricity exposes the film and may appear as lightning-like branches on the film. These will appear white on the slide or print and black on the negative.

> *Film moved too rapidly when advancing or rewinding.* In dry weather, advance and rewind film slowly to reduce the possibility of generating sufficient static electricity to cause a spark.

Light Streaked or Fogged

Film is light sensitive and if it is exposed to even small amounts of light (other than when the shutter is open) it will be streaked or fogged in the areas where the light struck. These areas appear light on prints or slides and dark on negatives. If you check the sprocket hole area of the film and find that negatives are darkened around the sprocket holes, or slides are lightened, then the light reached the film in the cassette or when the camera back was opened. If the edges are okay but the picture area has light streaks, then the light most likely came from lens flare.

> *Light entered film cassette.* The felt slit in the cassette through which the film leaves acts to keep unwanted light from the film. However, light can leak through it, especially in bright sunlight. Load your camera in the shade, or at least block direct light with your body. Keep film in its individual protective container before and after use.

> *Light entered camera.* If you open the camera back when it is loaded with film, the unwound portion will be heavily exposed but the film on the take-up spool will also be exposed, especially along the edges. If this happens, quickly close the camera and advance the film 3 or 4 frames to get to an unexposed portion that was still in the cassette when the camera was opened.

> *X-ray exposure.* Repeated exposure to airport X-ray security devices may fog film. The best solution is to ask politely for hand inspection. A sufficient number of airports are willing to do this to keep the overall dosage safe even on a trip that involves many stopovers. As an added prevention you can carry the film in lead-lined wrappers that are sold in camera stores.

▶ pp. 62–63

8 Preventing Problems

Care of Camera and Lens
Photographing in Bad Weather
Testing Your Film Speed

Exposure Compensation
Controls
Quick Guide to Exposure
Compensation

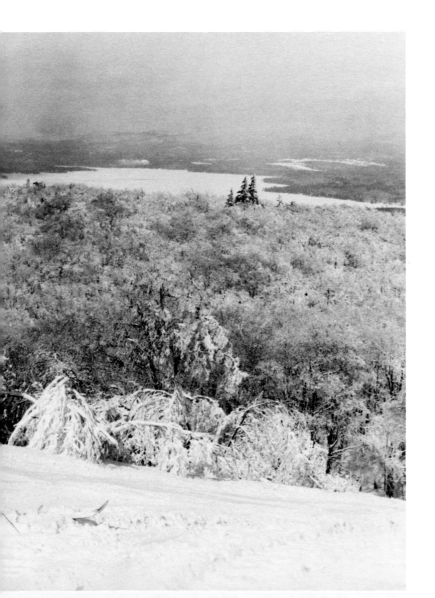

Care of Camera and Lens

To reduce the likelihood of having problems that affect your photographs, take good care of your camera and equipment. Avoid storing your camera where heat and dust can affect it, clean it only when necessary, and periodically vacuum your camera bag to reduce dust problems.

> *Viewfinder display failing* indicates problems with the batteries. Most cameras lose their automatic functions when their batteries fail, so it's wise to carry spares. If you are caught without any, remove the batteries and try cleaning their terminals and those in the camera with a pencil eraser.

> *Jammed lens attachments* can be removed by using a filter wrench available from your camera store. If you don't have such a wrench, try putting a small drop of penetrating oil in the seam where the lens and lens attachment meet. Tap the lens gently with your finger to help the oil penetrate and then try removing the filter. You can reduce the likelihood of this problem occurring if you lubricate the threads periodically and screw the filters on gently.

> *Film won't advance or rewind*. If the film won't advance you are probably at the end of the roll. Don't force the film advance lever. Depress the film rewind button and rewind the film into the cassette. If the film won't rewind, you may have advanced it past the last frame, jammed the film rewind control, or torn the film out of the cassette. To remove the film, find a dark closet or use a changing bag (a container into which your hands and camera—but no light—can go), open the camera and remove the film. The film can then be rewound by hand into the cassette or rolled up and sealed in the cassette's protective exterior container.

Cleaning the Lens (right). After dusting the lens with brush or blower, fold a piece of camera lens tissue three or four times to increase its thickness, tear off one end, then roll it up to form a tube with a soft brush-like end. Apply a drop of lens-cleaning fluid to the tissue, not directly onto the glass. Clean the lens surface with a circular motion; finish with a gentle wipe with a dry lens-cleaning tissue. Do not reuse tissues and avoid excessive or harsh cleaning; lens glass has a relatively delicate chemical coating.

Cleaning the Camera (below). When you load or unload film, blow or brush around the film path and winding mechanism to remove dust and the bits of film that occasionally break off. Angle the camera so the dust falls out and isn't pushed deeper inside. You can use a soft cloth to clean the pressure plate on the camera back, but avoid touching the fragile shutter curtains or the reflex mirror.

Photographing in Bad Weather

Some of the best opportunities for interesting photographs occur during bad weather. You can take advantage of these opportunities as long as you also take a few precautions to protect your camera.

Moisture from rain, mist, and spray can seriously affect an electronic automatic camera. When using it when these conditions exist, the camera should be protected as much as possible. The simplest technique is to insert the camera into a plastic bag, cut a hole for the lens to stick through, and seal the bag around it with a rubber band. The camera controls can be operated through the regular opening in the bag.

Screwing a relatively inexpensive skylight filter over the lens will allow you to wipe spray and condensation off when necessary without damaging the delicate lens surface.

Temperature extremes can have a noticeable effect on both film and camera. Cold weather affects batteries and moving camera parts and hot weather can seriously affect the film you are using. Whenever these extremes are expected, a few precautions are in order.

Heat. High temperatures can seriously affect the quality of your photographs whether encountered before, during, or after the film has been exposed. Never leave your film or camera in a car on a hot sunny day because temperatures there can build to very high levels. When high temperatures cannot be avoided, keep the film in an ice chest or an insulated bag. If the camera has to be exposed to the sun, such as when you are at the beach, cover it with a light-colored (sand free) towel or piece of tinfoil to shade it from the sun. Dark materials will only absorb the heat and possibly make things worse.

Cold. Cold affects camera functions by stiffening film and lubricants in moving parts and by reducing battery output. When using your camera in cold weather protect it as much as possible by carrying it under your coat until ready to use.

Condensation. If you photograph in cold weather and then take your camera into a warm room, the water vapor in the air can condense onto the camera body and lens. If you open the camera or remove the film before it returns to room temperature condensation can also build up inside the camera and on the film surface. To reduce the possibility of problems from condensation in extreme situations, put the camera in a plastic bag, squeeze out the excess air, and leave it in the bag until it returns to room temperature. This will allow the condensation to form on the outside of the bag rather than on the camera.

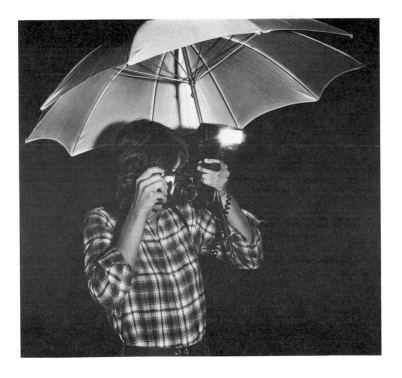

When caught in the rain, you don't have to miss the opportunity to take pictures. Protect the camera with a plastic bag or keep it dry with an umbrella.

Testing Your Film Speed

If your photographs are consistently too light or too dark, you may obtain better results—such as richer colors in your slides—by using a film speed other than the manufacturer's recommendation. All films, but particularly color slide films, are very sensitive to slight variations in exposure. All automatic cameras use the film speed (ASA, DIN or ISO) that you enter into the film speed dial to compute the correct exposure when a picture is taken. Because of slight variations in shutter speeds and apertures from camera to camera the film speed designated by the film manufacturer may not be the ideal one for your specific equipment.

The test for film speed explained opposite is done by *bracketing*. Using the film speed dial on your camera to control exposure, a normal exposure is made, then several other pictures of the same scene are taken, first at higher film speed settings (giving less exposure to the scene), then at lower film speed settings (giving more exposure). This produces a range of pictures that will vary from dark to light. For a film speed test, you want to examine small differences in exposure, so changes are slight, 1/3 stop each time.

You can also use bracketing as a technique to make sure you get at least one good exposure when a picture is very important to you or when the lighting situation is unusual. When you bracket for this purpose, start with the normal or automatic exposure; under-expose one or two shots in half- or full-stop increments, then over-expose one or two shots in half- or full-stop increments. You can bracket by adjusting the film speed dial, as shown opposite, by using the exposure compensation dial if your camera has one, or by operating the camera manually.

The Film Speed Dial. *Space limitations on the film speed dial usually prevent the camera manu-facturer from listing all of the ASA or DIN numbers. This illus-tration shows how to read the marks between the numbers on the dial.*

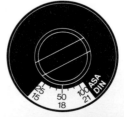

Film Speed Scale													
DIN	27	26	25	24	23	22	21	20	19	18	17	16	15
ASA	400	320	250	200	160	125	100	80	64	50	40	32	25

Finding Your Personal Film Speed Step-by-Step

Film to Use. *Color reversal (slide) film is the most sensitive to slight exposure variations. For this test try a medium-speed film, ASA 50 to 100 (DIN 18 to 21).*

Subject to Use. *Well-illuminated, colorful, front-lit subjects are best for testing. You may want to include in each exposure a card marked with the appropriate film speed setting.*

The First Picture. *Set the film speed dial on the speed recommended by the manufacturer. (Here the recommended film speed is ASA 64/DIN19.)*

Taking the Pictures. *Using the table below, take three additional exposures at 1/3-stop decreases in film speed, for example, ASA 50, 40, and 32, by turning the film speed dial to each of those settings and taking the same picture. Then take another three at 1/3-stop increases in film speed,*

for example, 80, 100, 125. Log each frame number (from the frame counter dial) into the chart below with the film speed setting used if different from the example shown.

Arrange the Results. *Process the slides, arrange in order of their frame numbers, and label according to film speed. If you lose track of the numbering, simply label the darkest slide with the highest film speed, the next to darkest slide with the next to highest speed, and so on.*

Choose the Best Film Speed. *Project the slides as normally viewed and select the exposure you like best. Notice that the slides taken at lower film speeds may have brighter colors and more detailed shadow areas. Those taken at higher film speeds may have richer, more saturated colors. Use the film speed of your best exposure for other photographs taken under similar conditions.*

Film Speed Test Log

Frame Number	Test Sequence	ASA, DIN, or ISO Setting Used	
		Example	Actual
	Recommended speed	ASA 64	
	1/3 stop lower speed	50	
	2/3 stop lower speed	40	
	1 stop lower speed	32	
	1/3 stop higher speed	80	
	2/3 stop higher speed	100	
	1 stop higher speed	125	

Exposure Compensation Controls

Many of the problems you encounter with pictures being too light or too dark result from your automatic exposure system being unable to handle certain kinds of lighting. Some of the common situations in which it is necessary to override your auto-exposure system to get perfect exposures are back-lit portraits (the sun is behind the subject), side-lit portraits (the sun is illuminating only one side of the subject), and scenes on bright sand and snow.

All 35mm SLR cameras provide one or more ways to override the automatic system to get the exposure you want. The illustration opposite shows all of them, although no camera has (or needs) all of these variations.

Stop down to decrease exposure and make picture darker.

Automatic exposure system is calibrated to give middle gray.

Open up to increase exposure and make picture lighter.

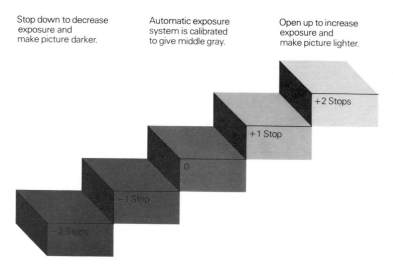

Exposure compensation lets you lighten or darken the photograph that the camera would produce if operated automatically. To lighten a picture, you need to increase the exposure; to darken, you need to decrease the exposure.

The amount you increase or decrease the exposure is measured in "stops." Each aperture setting is one stop from the next setting; each lets in half the light of the next widest setting. Photographers also speak of shutter speeds as being one stop apart (even though the term originally described apertures). Each shutter speed setting is one stop from the next; it lets in half the light of the next slower shutter speed.

Memory Lock
A memory lock temporarily locks in an exposure so you can move up close to take a reading of a particular area, lock in the desired setting, step back, and then photograph the entire scene. Only a few of the more expensive cameras have this device.

Backlight Button
Depressing a backlight button adds a fixed amount of exposure (usually 1 to 1½ stops) and lightens the picture. It cannot be used to decrease exposure. A camera may have this device if it does not have an exposure compensation dial.

Exposure Compensation Dial
Moving the dial to +1 or +2 increases the exposure and lightens the picture (some dials say X2 or X4 for equivalent settings). Moving the dial to −1 or −2 (X½ or X¼ on some dials) decreases the exposure and darkens the picture.

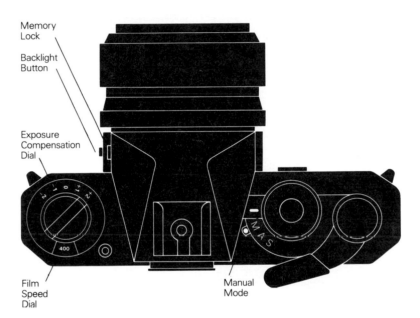

Memory Lock

Backlight Button

Exposure Compensation Dial

Film Speed Dial

Manual Mode

Film Speed Dial
You can increase or decrease exposure by changing the film speed dial. The camera then responds as if the film is slower or faster than it really is. With ASA-rated film, doubling the film speed (for example, from ASA 100 to ASA 200) darkens the picture by decreasing the exposure one stop. Halving the film speed (for example, from ASA 400 to ASA 200) lightens the picture by increasing the exposure one stop. (With European DIN-rated films, every increase of 3 in the rating is the same as doubling an ASA-rated film. DIN 21 is equivalent to ASA 100; DIN 24 is equivalent to ASA 200.) See pp. 40-41. Even if a camera has no other means of exposure compensation, you can always use the film speed dial.

Manual Mode
In manual mode, you adjust the shutter speed and aperture yourself. Exposure can be increased to lighten the picture or decreased to darken it as you wish. Many cameras have a manual mode though some less expensive models do not.

Quick Guide to Exposure Compensation

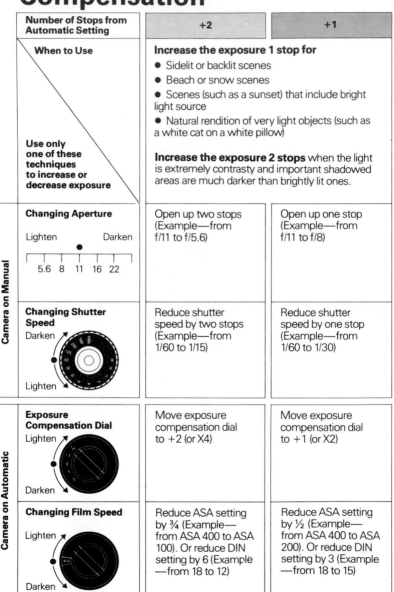

Number of Stops from Automatic Setting	+2	+1
When to Use **Use only one of these techniques to increase or decrease exposure**	**Increase the exposure 1 stop for** ● Sidelit or backlit scenes ● Beach or snow scenes ● Scenes (such as a sunset) that include bright light source ● Natural rendition of very light objects (such as a white cat on a white pillow) **Increase the exposure 2 stops** when the light is extremely contrasty and important shadowed areas are much darker than brightly lit ones.	
Camera on Manual — **Changing Aperture** Lighten Darken 5.6 8 11 16 22	Open up two stops (Example—from f/11 to f/5.6)	Open up one stop (Example—from f/11 to f/8)
Camera on Manual — **Changing Shutter Speed** Darken Lighten	Reduce shutter speed by two stops (Example—from 1/60 to 1/15)	Reduce shutter speed by one stop (Example—from 1/60 to 1/30)
Camera on Automatic — **Exposure Compensation Dial** Lighten Darken	Move exposure compensation dial to +2 (or X4)	Move exposure compensation dial to +1 (or X2)
Camera on Automatic — **Changing Film Speed** Lighten Darken	Reduce ASA setting by ¾ (Example—from ASA 400 to ASA 100). Or reduce DIN setting by 6 (Example—from 18 to 12)	Reduce ASA setting by ½ (Example—from ASA 400 to ASA 200). Or reduce DIN setting by 3 (Example—from 18 to 15)

0	−1	−2
Use the exposure set automatically for scenes that are evenly lit as viewed from camera position and when important shadowed areas are not too much darker than brightly lit ones.	**Decrease the exposure 1 stop for** ● Scenes where the background is much darker than the subject (such as a portrait in front of a very dark wall) ● Natural rendition of very dark objects (such as a black cat on a black pillow) **Decrease the exposure 2 stops** for scenes of unusual contrast, as when an extremely dark background occupies a very large part of the image.	
Leave aperture unchanged	Close down one stop (Example—from f/11 to f/16)	Close down two stops (Example—from f/11 to f/22)
Leave shutter speed unchanged	Increase shutter speed by one stop (Example—from 1/60 to 1/125)	Increase shutter speed by two stops (Example—from 1/60 to 1/250)
Leave exposure compensation dial unchanged	Move exposure compensation dial to −1 (or X½)	Move exposure compensation dial to −2 (or X¼)
Leave ASA or DIN setting unchanged	Multiply ASA setting by 2 (Example—from ASA 400 to ASA 800). Or increase DIN setting by 3 (Example—from 12 to 15)	Multiply ASA setting by 4 (Example—from ASA 400 to ASA 1600). Or increase DIN setting by 6 (Example—from 12 to 18)

9 Improving Good Pictures

Introduction/Color Correction
Removing Spots from Prints

Cropping for Better
Composition
Burning-in and Dodging

Introduction/Color Correction

Ansel Adams, who is renowned for his photographic technique as well as for his landscapes, once stated, "The negative is the score but the print is the performance." By this he meant that although the exposure of the negative is a large part of a good image, many things can be done at the time a print is made to refine the results. Even if you don't have a darkroom, you still have access to several techniques to improve your images. Some you can do yourself, like spotting (opposite) or deciding how to crop a print (pp. 128–129). In addition, custom processing labs provide special services that you can request, usually at some additional cost, to eliminate defects or otherwise improve images you really like. This chapter covers some of the more popular services offered by these labs.

The best way to find a good lab is to ask an active photographer in your area to recommend one. That way you won't have to go through as much trial and error to find a lab that combines reliable service and fair prices. Write directly to the lab, or visit if you can, to obtain a description of their services and a price list. If you are unsure of exactly how an image can be improved, ask the lab's advice. You can also ask them to use their own judgment with improvements that can be hard to describe exactly, such as color corrections, but do give them a basic idea of what you want changed.

Color Correction. Images that have an undesirable color tint can sometimes be improved when prints are made or slides are duplicated. The lab can change the overall color balance of a print or slide by inserting the appropriate colored filter in the enlarger or duplicator. Color prints can also have local color changes made by using dyes that are rubbed into portions of the print to deepen colors or to change color balance slightly. Not all color problems can be completely corrected but many can at least be improved.

Removing Spots from Prints

Spots on prints are usually caused by dust or dirt (see p. 104). These spots can be minimized or removed by spotting (painting) the print with dyes to darken light spots or by etching (scraping) dark spots off the print.

Spotting a Print. This print shows the corrected version of the print on p. 104 (left). The white specks and blotches were removed by spotting, using a fine-tipped brush and photographic spotting dyes, such as Spotone, to match each spot to the surrounding print tone. When color prints are spotted, colored dyes are used.The print on p. 104 is an extreme case; ordinarily you only have to deal with much smaller specks. You can ask a lab to spot your prints or you can learn to do this yourself. Spotting dyes are available in photographic stores.

Etching a Print. The dark specks on the print on p. 104 (right) were removed by etching. An X-acto knife blade was used to scrape the surface of the print all or part of the way down to the white paper base. You can ask the lab to etch out a dark speck or try to do it yourself. Etching is easiest to do with black-and-white prints on regular-base papers. Color prints or prints on resin-coated (RC) papers seldom can be etched successfully; sometimes dark specks on these prints can be improved by covering the speck with white opaquing fluid, then spotting the resultant white spot. Do not etch a slide.

Cropping for Better Composition

Although most photographers agree that it is better to compose an image in the viewfinder at the time a picture is taken, there are times when an image can be improved after studying the print or slide at your leisure. Cropping—trimming the edges of an image—can be used to straighten a tilted horizon, eliminate distracting elements, or enlarge small portions of the photograph when a new print is made.

To evaluate a slide or print for cropping, first cut out two ''L'' shapes from a piece of paper or cardboard (their size is determined by the size of the image you are evaluating). By arranging the L's in various configurations, any size and shape rectangle can be formed to isolate a portion of the image (see pp. 124–125). When you decide how you want to crop, mark straight lines onto the borders of the print (or onto the slide mount) to line up with the edges of the new cropping. Now you can either trim an existing print accordingly or get a duplicate slide or an enlarged print made with the new cropping.

Straightening a Horizon. The tilted horizon line in the photograph on *p. 32 was made level by cropping the image so the horizon was parallel to the top and bottom of the frame. A portion of the image was lost, but the result of the straightening was worth the small sacrifice.*

Eliminating Vignetting. *The vignetted image on p. 102 was cropped to eliminate the darkened corners. Portions of the image along all four edges were lost, but this did not present a problem here.*

Enlarging a Portion of an Image. *If your picture seems uninteresting or dull, it may be possible to improve it by enlarging the most important part of it. Left: By selecting a portion of the image for enlargement, pictures such as the one on p. 40 can sometimes be improved. Below: The photograph on p. 36 was taken from too far away. The photographer decided to crop it to emphasize the panoramic aspects of the scene. You should feel free to crop your pictures to any format that appeals to you.*

Burning-in and Dodging

To make a print, a negative is inserted into an enlarger and the image projected onto a sheet of sensitized paper. The overall lightness or darkness of a print is controlled much as you control the initial exposure of the negative, by increasing or decreasing the enlarger lens aperture or by changing the length of time that the printing paper is exposed. If portions of the print are too light or too dark in relation to the overall image, a human operator can intervene to darken (by burning-in) or to lighten (by dodging) those specific areas.

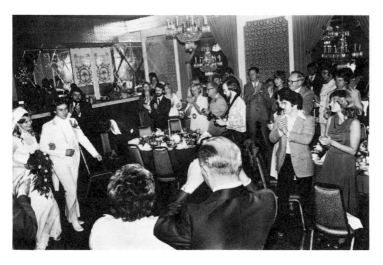

Making Areas Darker by Burning-in. After the initial printing exposure, selected areas can be made darker by giving only those areas additional exposure. This technique, called burning-in, can be used to darken highlight areas to show increased detail. Occasionally, it can be used to darken skies to make clouds stand out better. Above, burning-in was used to darken the couple in the foreground. Page 92 shows the uncorrected print: the couple was overexposed and too light because they were standing too close to the photographer's flash.

Making Areas Lighter by Dodging. *Portions of a print can be made lighter than they normally would be by holding back light from those areas during part of the printing exposure. This technique, called dodging, can be used to lighten shaded areas—for example, someone's face in a backlit portrait. There are limits to how much an area can be lightened because too much dodging will make the area look unnaturally grayish. In the picture on p. 52 the face is in complete shadow. It could be lightened only slightly (above left), but it was enough to show the man's expression. The flash picture on p. 91 was underexposed and too dark. Here (above right) the faces and part of the bride's dress were lightened by dodging so that the underexposure is less noticeable.*

Useful Terms

Prepared by Lista Duren

angle of view The amount of a scene that can be recorded by a particular lens; determined by the focal length of the lens.

aperture The lens opening formed by the iris diaphragm inside the lens. The size is variable and is controlled by the aperture ring on the lens.

aperture-priority mode An automatic exposure system in which the photographer sets the aperture (f-stop) and the camera selects a shutter speed for correct exposure.

ASA A number rating that indicates the speed of a film. Stands for American Standards Association. See also **film speed.**

automatic exposure A mode of camera operation in which the camera automatically adjusts the aperture, shutter speed, or both for proper exposure.

automatic flash An electronic flash unit with a light-sensitive cell that determines the length of the flash for proper exposure by measuring the light reflected back from the subject.

bounce light Indirect light produced by pointing the light source away from the subject and using a ceiling or other surface to reflect the light back toward the subject. Softer and less harsh than direct light.

bracketing Taking several photographs of the same scene at different exposure settings, some greater than and some less than your first exposure, to ensure a well-exposed photograph.

color balance The overall accuracy with which the colors in a color photograph match or are capable of matching those in the original scene. Color films are balanced for use with specific light sources.

contrast The difference in brightness between the light and the dark parts of a scene or photograph.

contrasty Having greater-than-normal differences between light and dark areas.

cool Toward the green-blue-violet end of the visible spectrum.

daylight film Color film that has been balanced to produce natural-looking color when exposed in daylight. Images will look reddish if daylight film is used with tungsten light.

depth of field The distance between the nearest and farthest points that appear in acceptably sharp focus in a photograph. Depth of field varies with lens aperture, focal length, and camera-to-subject distance.

diffused light Light that has been scattered by reflection or by passing through a translucent material. Produces an even, often shadowless, light.

DIN A number rating used in Europe that indicates the speed of a film. Stands for Deutsche Industrie Norm. See also **film speed.**

direct light Light shining directly on the subject and producing strong highlights and deep shadows.

electronic flash (strobe) A camera accessory that provides a brilliant flash of light. A battery-powered unit requires occasional recharging or battery replacement, but unlike a flashbulb can be used repeatedly.

exposure 1. The act of allowing light to strike a light-sensitive surface. 2. The amount of light reaching the film, controlled by the combination of aperture and shutter speed.

exposure meter (light meter) A device built into all automatic cameras that measures the brightness of light.

exposure mode The type of camera operation (such as manual, shutter-priority, aperture-priority) that determines which controls you set and which ones the camera sets automatically. Some cameras operate in only one mode. Others may be used in a variety of modes.

film speed The relative sensitivity to light of photographic film. Measured by ASA, DIN, or ISO rating. Faster film (higher number) is more sensitive to light and requires less exposure than does slower film.

filter A piece of colored glass or plastic placed in front of the camera lens to alter the quality of the light reaching the film.

fisheye lens An extreme wide-angle lens covering a 180° angle of view. Straight lines appear curved at the edge of the photograph, and the image itself may be circular.

flare Stray light that reflects between the lens surfaces and results in a loss of contrast or an overall grayness in the final image.

flat Having less-than-normal differences between light and dark areas.

focal length The distance from the optical center of the lens to the film plane when the lens is focused on infinity. The focal length is usually expressed in millimeters (mm) and determines the angle of view (how much of the scene can be included in the picture) and the size of objects in the image. The longer the focal length, the narrower the angle of view and the more that objects are magnified.

focal plane See **film plane.**

frame 1. A single image in a roll of film. 2. The edges of an image.

f-stop (f-number) A numerical designation (f/2, f/2.8, etc.) indicating the size of the aperture (lens opening).

ghosting 1. Bright spots in the picture the same shape as the aperture (lens opening) caused by reflections between lens surfaces. 2. A blurred image combined with a sharp image in a flash picture. Can occur when a moving subject in bright light is photographed at a slow shutter speed with flash.

guide number A number on a flash unit that can be used to calculate the correct aperture for a particular film speed and flash-to-subject distance.

hand hold To support the camera with the hands rather than with a tripod or other fixed support.

hot shoe A clip on the top of the camera that attaches a flash unit and provides an electrical link to synchronize the flash with the camera shutter.

ISO A number rating that combines the ASA and DIN film speed ratings. Stands for International Standards Organization. See also **film speed.**

lens hood (lens shade) A shield that fits around the lens to prevent extraneous light from entering the lens and causing ghosting or flare.

light meter See **exposure meter.**

long-focal-length lens (telephoto lens) A lens that provides a narrow angle of view of a scene, including less of a scene than a lens of normal focal length and therefore magnifying objects in the image.

manual exposure A nonautomatic mode of camera operation in which the photographer sets both the aperture and the shutter speed.

negative 1. An image with colors or dark and light tones that are the opposite of those in the original scene. 2. Film that was exposed in the camera and processed to form a negative image.

normal-focal-length lens (standard lens) A lens that provides about the same angle of view of a scene as the human eye and that does not seem to magnify or diminish the size of objects in the image unduly.

open up To increase the size of the lens aperture. The opposite of stop down.

overexposure Exposing the film to more light than is needed to render the scene as the eye sees it. Results in a too dark (dense) negative or a too light positive.

pan To move the camera during the exposure in the same direction as a moving subject. The effect is that the subject stays relatively sharp and the background becomes blurred.

positive An image with colors or light and dark tones that are similar to those in the original scene.

print An image (usually a positive one) on photographic paper, made from a negative or a transparency.

reciprocity effect (reciprocity failure) A shift in the color balance or the darkness of an image caused by very long or very short exposures.

reversal film Photographic film that produces a positive image (a transparency) upon exposure and development.

short-focal-length lens (wide-angle lens) A lens that provides a wide angle of view of a scene, including more of the subject area than does a lens of normal focal length.

shutter The device in the camera that opens and closes to expose the film to light for a measured length of time.

shutter-priority mode An automatic exposure system in which the photographer sets the shutter speed and the camera selects the aperture (f-stop) for correct exposure.

shutter speed dial The camera control that selects the length of time the film is exposed to light.

silhouette A dark shape with little or no detail appearing against a light background.

single-lens reflex (SLR) A type of camera with one lens which is used both for viewing and for taking the picture.

slide A positive image on a clear film base viewed by passing light through from behind with a projector or light box. Usually in color.

SLR See **single-lens reflex.**

standard lens See **normal-focal-length lens.**

stop 1. An aperture setting that indicates the size of the lens opening. 2. A change in exposure by a factor of two. Changing the aperture from one setting to the next doubles or halves the amount of light reaching the film. Changing the shutter speed from one setting to the next does the same thing. Either changes the exposure one stop.

stop down To decrease the size of the lens aperture. The opposite of open up.

strobe See **electronic flash.**

synchronize To cause a flash unit to fire while the camera shutter is open.

telephoto lens See **long-focal-length lens.**

35mm The width of the film used in the cameras described in this book.

transparency See **slide.**

tripod A three-legged support for the camera.

tungsten film Color film that has been balanced to produce natural-looking color when exposed in tungsten light. Images will look bluish if tungsten film is used in daylight.

underexposure Exposing the film to less light than is needed to render the scene as the eye sees it. Results in a too light (thin) negative or a too dark positive.

vignette To shade the edges of an image so they are underexposed and dark. A lens hood that is too long for the lens will cut into the angle of view and cause vignetting.

warm Toward the red-orange-yellow end of the visible spectrum.

wide-angle lens See **short-focal-length lens.**

Index

Aperture, and picture sharpness, 11, 72–75

Background
distracting, 44–45, 130; sharpness of, 72–75; subject dark against light, 9, 52–53; subject light against dark, 54–55
Blue cast, to color pictures, 18–19
Blurring, 56, 68–71. *See also* Sharpness
Burning-in, to darken print, 130

Camera, caring for, 114–115
Camera handling, 6–7; and blurred images, 68–69; distorted subjects, 38–39; distracting backgrounds, 44–45; entire scene not in picture, 34–35; main subject small, 36–37; and picture's center of interest, 40–41; reflections show, 42–43; tilted horizon line, 32–33; vertical line convergence, 30–31; your shadow in picture, 28–29
Camera-to-subject distance: and flash problems, 90, 91; and freezing action, 70; and picture sharpness, 72, 74, 76. *See also* Subject positioning
Candlelight, and color film, 20
Center of interest, picture's, 40–41, 129
Close-up photography, 36
Clouds, darkening, 64–65, 130
Color photography, 12–13; blue cast, 18–19; color corrections during processing, 126; colors not rich and bright, 16–17; nighttime, 57; orange-red cast, 20–21; unexpected casts, 24–25; yellow-green cast, 22–23
Condensation, in camera, avoiding, 117
Contrast: causes of low, 60–62; problems with high, 52–55
Corners dark, 102–103; cropping to eliminate, 128
Cropping, for better composition, 128–129

Dark pictures, 50; correcting by dodging, 131; with flash, 91, 94–95, 96, 97
Depth of field, and picture sharpness, 11, 72–75, 76. *See also* Selective focus
Detail, photographing, 34–35
Distortion, subject, 7, 38–39
Dodging, to lighten picture, 130, 131
Double exposure, 108–109

Edges dark, using flash, 96
Enlarging, part of picture, 129
Exposure compensation, 120–123

Exposure problems, 8–9; colors not rich and bright, 16–17; contrast very low, 60–61; lens flare, 62–63; at night, 56–57; no picture at all, 48–49; overexposed skies, 64–65; part or uneven exposure, 82, 100–101; pictures too dark or light, 50–51; snow and fog too gray, 58–59; subject dark against light background, 52–53; subject light against dark background, 56–57
Eyeglass reflections, 85

Film: color balance of, 18, 20, 22, 24; dust on, 104; problems advancing or rewinding, 114; scratches or marks on, 105–106; torn sprocket holes on, 107; unintended exposure of, 111
Film speed, testing, 118–119
Filters: causing dark corners, 102; for controlling color shifts, 18, 19, 22, 126; for darkening skies, 64–65; flare problems with, 62; polarizing, 42, 64
Firelight, and color film, 20
Flare, lens, 17, 60, 62–63
Flash problems: dark edges, 96; "ghosts," 83; harsh shadows, 86–87; loss of texture or volume, 88–89; at night or in large rooms, 97; part exposed, 82; part right/part light or dark, 92–95; reflections, 84–85; subject too light or dark, 90–91
Fluorescent light, and color film, 22–23
Focusing problems, 76–77. *See also* Selective focus; Sharpness
Fogged film, causes of, 111
Foggy day, effect on contrast, 60, 61
Fog scenes, too gray, 59
Foreground, sharpness of, 72–75
Fuzzy image, causes of, 78–79

"Ghosts," flash, 83
Gray, pictures too, 58–59
Green cast, in color pictures, 22–23
Groups, photographing, 34, 92

High altitudes, and color film, 18
Horizon line, tilting of, 32–33; cropping to eliminate, 128

Large rooms, flash problems in, 97
Lenses: caring for, 114–115; effects of dirt on, 60, 78, 104; and flash problems, 96; poor quality, 78

Lens hood, wrong size, effects of, 102
Light pictures, 50; correcting by burning-in, 130; with flash, 91, 92–93, 97
Light-streaked film, causes of, 111
Lines, on film, causes of, 105, 106

Mixed lighting, and color film, 24, 57
Motion, blurring of, 70–71

Nighttime photography, 56–57; using flash, 97

Orange-red cast, to color pictures, 20–21
Overcast day, and color film, 18
Overlapping images, 108–109

Partial exposure, 82, 100
Portraits, 36, 38, 85

Reciprocity effect, and color film, 24, 25, 57
Redeye effect, 85
Reflections, 42–44; effect on subject color, 24; using flash, 84–85

Selective focus: to create center of interest, 40; to eliminate distracting background, 44
Shade, and color film, 18
Shadows: harsh, using flash, 86–87; your own, in picture, 28–29
Sharpness problems, 10–11; blurred image, 68–69; fuzzy image, 78–79; moving subjects blurred, 70–71; unfocused background, 72–73; unfocused

foreground, 74–75; wrong part focused, 76–77
Shutter speed: and blurred image, 10, 68, 70–71; and flash problems, 82, 83
Sky, darkening, 64–65
Snow scenes, too gray, 16, 58
Spots, on picture, 104; removing from prints, 127
Static marks, on film, 110
Subject positioning, 6–7; and center of interest, 40–41; and distracting background, 44–45; and flash problems, 92, 94; overall coverage vs. detail in, 34–35

Temperature extremes, effect on equipment, 116–117
Texture, loss of, using flash, 88–89

Uneven exposure, across frame, 101

Vertical lines, converging of, 30–31
Viewing environment, for prints and slides, 4–5
Vignetted images, 96, 102–103; cropping to eliminate, 128
Volume, loss of, using flash, 88–89

Weather conditions, photographing in bad, 104, 110, 116–117

X-ray exposure, effect on film, 111

Yellow-green cast, in color pictures, 22–23

Photo Credits

2–3, Department of Agriculture; 6 (left), Donald Dietz; 6 (right), Peggy Cole; 7 (top), Dennis Curtin; 7 (bottom), Barbara Marshall; 8 (top), Rick Ashley; 8 (bottom), Jean Shapiro; 9 (top), Joe Wrinn; 9 (bottom), Flint Born; 10 (top), Willard Traub; 10 (bottom), Donald Dietz; 11 (top left and bottom), Margaret Thompson; 11 (top right), Barbara Marshall; 12 (top), David Krathwohl; 12 (bottom), M. Woodbridge Williams; 13 (top), Larry Lorusso; 13 (bottom), Rick Ashley; 14–15, Sharyn J. LaHaise; 16, Lista Duren; 17 (top), Willard Traub; 17 (bottom), Terry McKoy; 18, Richard Farrell; 19 (top), Nancy LeMay; 19 (bottom), Donald Dietz; 20, Betty Williams; 21 (top), Tom Pantages; 21 (middle), Terry McKoy; 21 (bottom), Fuji Film; 22, Elizabeth Hamlin; 23 (top), Larry Lorusso; 23 (middle), Susan Lapides; 23 (bottom), Jean Shapiro; 24, Donald Dietz; 25 (top), Peter Laytin; 25 (bottom), Environmental Protection Agency; 26–27, A. Samuel Laundon; 28, Dennis Curtin; 29 (top), Margaret Thompson; 29 (bottom), A. Samuel Laundon; 30 (left), Fred Bodin; 30 (right), Alan Oransky; 31 (top), David Morrison; 31 (bottom), EPA-Documerica, Dan McCoy; 32, Fred Bodin; 33 (top), Cynthia Benjamins; 33 (bottom), Margaret Thompson; 34, Willard Traub; 35 (top and middle), Barbara Marshall; 35 (bottom), Fred Bodin; 36, Larry Lorusso; 37 (top left, top right, and bottom), Fred Bodin; 38, Fred Bodin; 39 (top), Ken Kobre; 39 (bottom), Joe DeMaio; 40, Larry Lorusso; 41 (top), Elizabeth Hamlin; 41 (bottom), William Edward Smith; 42, Donald Dietz; 43 (top), Joe DeMaio; 43 (bottom), David Morrison; 44, Elizabeth Hamlin; 44 (top left and right), Fred Bodin; 44 (bottom), Terry McKoy; 46–47, Joe Wrinn; 50, Fred Bodin; 51, Lista Duren; 52, Nancy Benjamin; 53 (top), Larry Lorusso; 53 (bottom left), Barbara Marshall; 53 (bottom right), Bobbi Knafels; 54, Alan Oransky; 55 (top left and right), Hillary Liss; 55 (bottom), Margaret Thompson; 56, Jean Shapiro; 58, Fred Bodin; 59, Fred Bodin; 60, Dennis Curtin; 61 (top and bottom), Fred Bodin; 62, Dennis Curtin; 63 (top), Barbara Marshall; 63 (bottom), Fred Bodin; 64, Barbara Marshall; 65 (top and bottom), Barbara Marshall; 66–67, Patti Gold; 68, William Edward Smith; 69 (top), Environmental Protection Agency; 69 (bottom), Ben DeSoto; 70, Dennis Curtin; 71 (top), A. Samuel Laundon; 71 (bottom), Dennis Curtin; 72, Larry Lorusso; 73 (top left), Jean Shapiro; 73 (top right), Barbara Marshall; 73 (bottom), Peggy Cole; 74, Fred Bodin; 75 (top left), Dennis Curtin; 75 (top right), Barbara Marshall; 75 (bottom), Fred Bodin; 76, Willard Traub; 77 (top), Peggy Cole; 77 (bottom), Fred Bodin; 78, Fred Bodin; 79 (top), Dennis Curtin; 79 (bottom), Joe DeMaio; 80–81, Colleen Chartier; 82, Ron Carraher; 83, Ken Kobre; 84, Donald Dietz; 85, Flint Born; 86, Marjorie Masel; 87 (top), Jean Shapiro; 87 (bottom), Flint Born; 88, Elizabeth Hamlin; 89 (top), Susan Lapides; 89 (bottom), Ron Carraher; 90, Elizabeth Hamlin; 91, Elizabeth Hamlin; 92, Rick Ashley; 93 (top), Mike Rizza; 93 (bottom), David Dubuque; 94, Margaret Thompson; 95 (top), Colleen Chartier; 95 (bottom left), Susan Lapides; 95 (bottom right), Jim Ball; 96, Alan Oransky; 97, Alan Oransky; 98–99, John Littlewood; 100, Fred Bodin; 101, Lista Duren; 102, Willard Traub; 103 (top), David Krathwohl; 103 (bottom), Willard Traub; 104 (top left and right), A. Samuel Laundon; 105, A. Samuel Laundon; 106, Lista Duren; 108, Dennis Curtin; 109 (top), Ken Kobre; 109 (bottom), William Edward Smith; 110, David Krathwohl; 111, Fred Bodin; 112–113, Jerry Howard; 117, Ron Carraher; 124–125, Willard Traub; 127 (left and right), A. Samuel Laundon; 128, Fred Bodin; 129 (top), Willard Traub; 129 (middle and bottom), Larry Lorusso; 130, Rick Ashley; 131 (top left), Nancy Benjamin; 131 (top right), Elizabeth Hamlin